Painting
David Curtis
and Robin Capon
with Impact

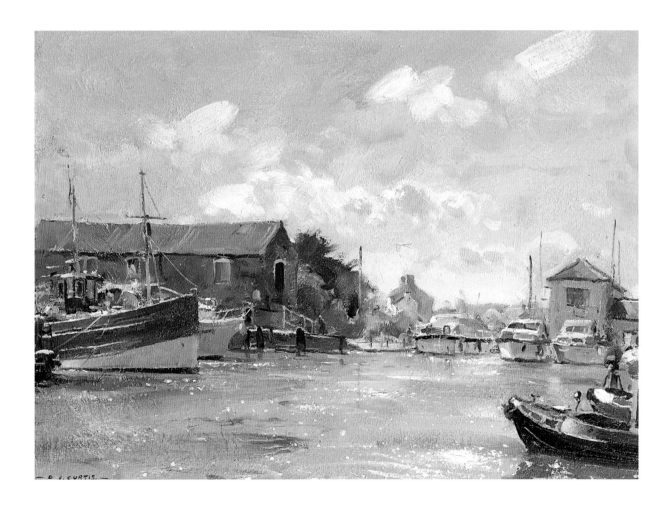

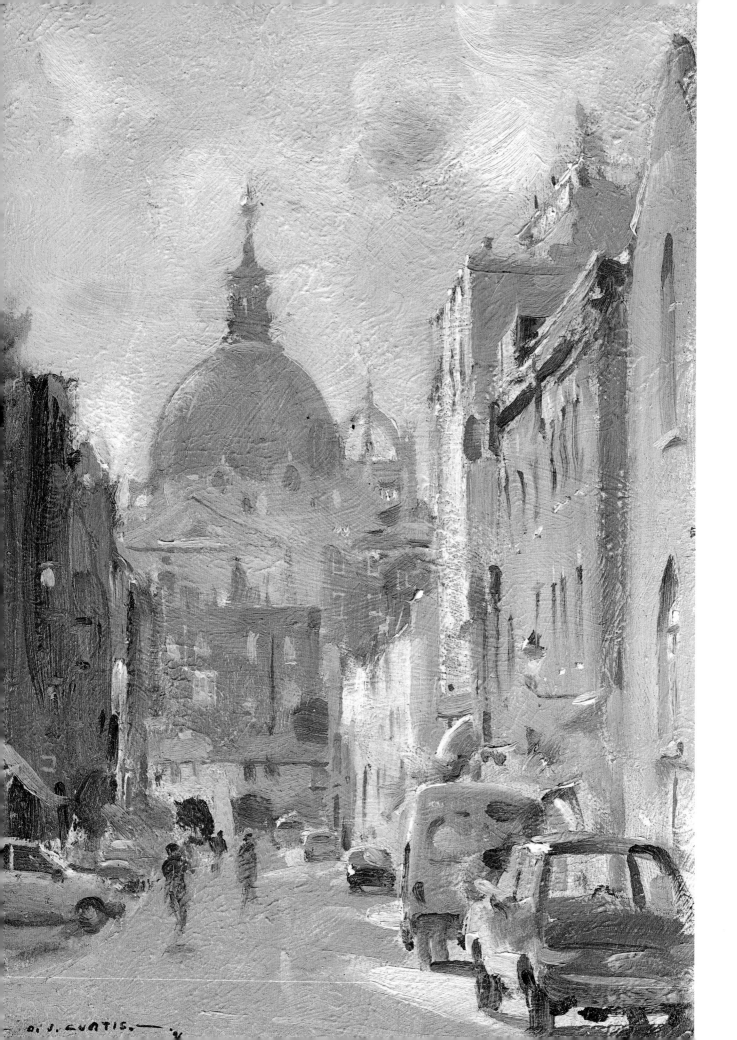

Painting

David Curtis
and Robin Capon

with Impact

BATSFORD

To my family, friends and painting companions.

Acknowledgements

My special thanks to Robin Capon for his patient hard work on the text.
As with the two previous books, *Light and Mood in Watercolour* and
Capturing the Moment in Oils, it has been a pleasure to collaborate with him.
www.djcurtis.co.uk
david@djcurtis.co.uk
David Curtis is represented by Richard Hagen, Stable Lodge, Broadway,
Worcestershire WR12 7DP. Tel: 01386 853624; www.richardhagen.com.

First published in the United Kingdom in 2010 by
Batsford
10 Southcombe Street
London W14 0RA
An imprint of Anova Books Company Ltd

ISBN-13: 9781906388430

A CIP catalogue record for this book is available from the British Library.

15 14 13
10 9 8 7 6 5 4 3 2

Repro by Rival Colour Ltd, UK
Printed by Craft Print International Ltd, Singapore

This book can be ordered direct from the publisher at the website:
www.anovabooks.com, or try your local bookshop.

Distributed in the United States and Canada by Sterling Publishing Co.,
387 Park Avenue South, New York, NY 10016, USA

Page 1:

West Stockwith Basin

OIL ON PREPARED BOARD

25.5 x 35.5cm (10 x 14in)

Page 2:

**Towards Bonhams,
South Kensington**

OIL ON PREPARED BOARD

25.5 x 18cm (10 x 7in)

Contents

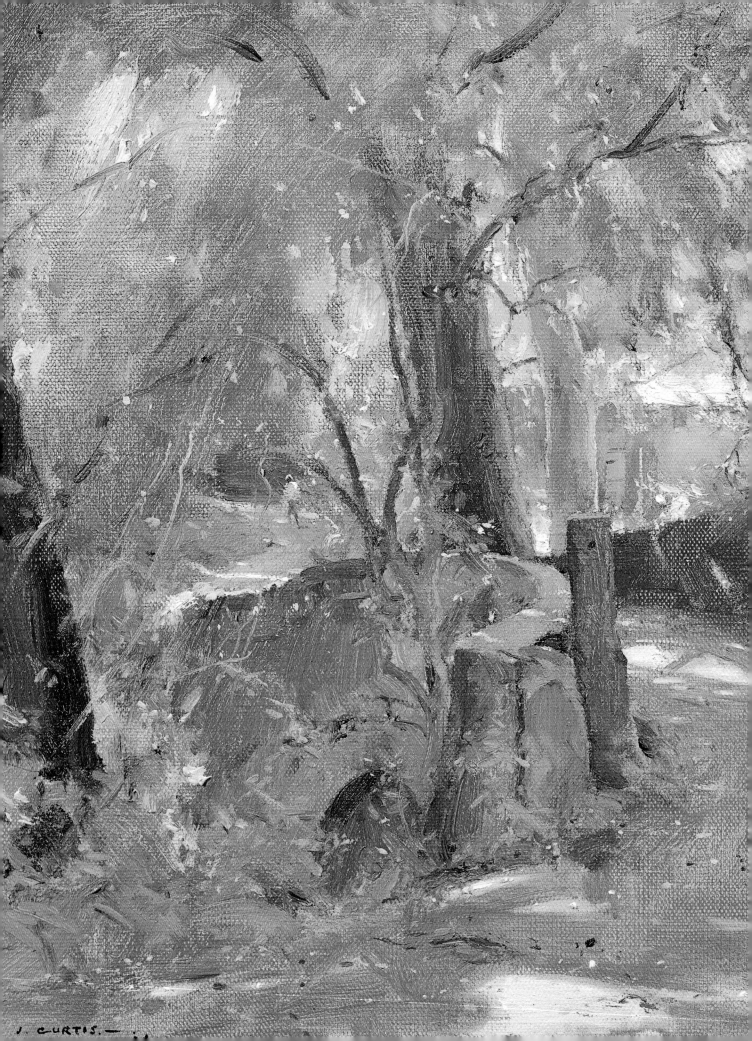

J. CURTIS.

Introduction

Impact in painting is influenced and determined by a variety of factors, not least by the enthusiasm, skill and experience of the artist concerned. We all have good days and bad days, but essentially, to consistently create interesting work, we need to maintain a degree of 'hunger' and excitement. Sometimes this is difficult – especially if, like me, you have been painting for more than 40 years. However, I can truthfully say that now, with the advantage of the knowledge and experience that I have gained over the years, I am just as eager as ever to find new subjects and capture my thoughts and feelings about them in paint.

Bridge in the Cordwell Valley, Derbyshire

OIL ON CANVAS BOARD

30.5 x 30.5cm (12 x 12in)

" *Impact can also come from the expressive power of the medium itself, as in this* plein-air *oil painting.* "

David Curtis

I heard a comment recently from a painting colleague who advised that: 'It is a good idea to give the paints a rest for a while now and again'. In fact, for me, that 'while' can only extend for a day or so before I start to suffer from the inevitable withdrawal symptoms. I doubt if I have ever stopped painting for any extended period of time and I am eternally grateful for that. In my view, there is a danger that, without a consistency of application, the vitality and 'edge' in painting could be lost and the all-important physical skills and technical ability could be compromised. This is perhaps an unfounded fear, but one that is nonetheless present.

I certainly believe that, to keep the challenging process of painting moving forward and gaining in confidence and effect, it is essential to work as often as possible and with due determination and perseverance. To paint with impact relies on commitment, just as it does on an ability to recognize the potential in subjects and to make the most of that potential in creating work that is successful, both in terms of originality and feeling as well as skill.

Impact starts with the subject matter. Ideally, this should be something that excites and inspires you – something that you feel you *must* paint. The attraction could come from the actual content of the subject matter, or from a particular light effect, colour, mood or similar quality – it doesn't have to be blatantly obvious. Impact is usually more successful if achieved through subtlety, rather than through effects that shout out to the viewer.

Evening, Lifeboat Day, Staithes

WATERCOLOUR ON ARCHES ROUGH

39 x 57cm (15¼ x 22½in)

Impact starts with the subject matter. I loved the sense of atmosphere and activity in this wonderful, late-evening scene.

Of course, style, originality and technique also play their part. However, in my experience it is often the small, profound passages within a painting that will attract interest, encouraging the viewer to look more closely and start to interpret and respond to the work. As well as the planned aims and effects, there are usually opportunities that arise during the painting process to enhance the impact – by responding to a fleeting light effect, for example, or the chance to place an interesting figure or improve the composition.

From the choice of subject matter to different materials and techniques, every decision influences the development of the painting and its degree of success. In this book I consider both *plein-air* studies and studio work, and examine every stage of the working process, showing how each is important in contributing to the ultimate impact of the painting. All paintings should offer something emotive and unique, I think, and these are the qualities that I continue to aim for, even in my most quiet, close-toned subjects.

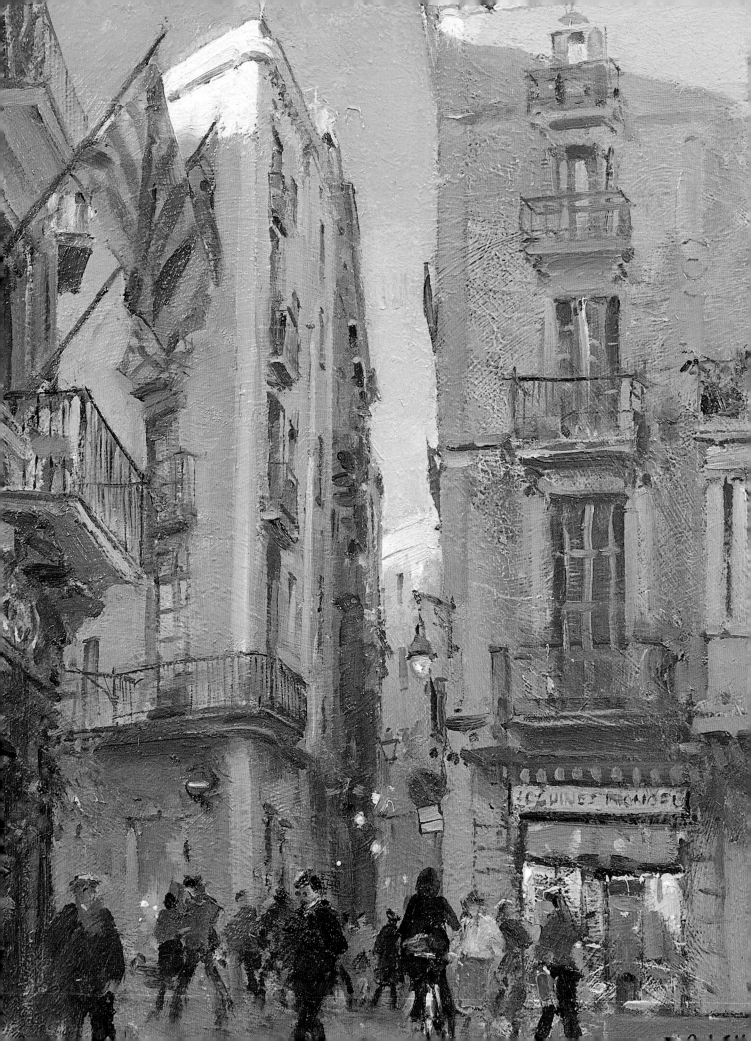

A Personal View

For me, there is no greater thrill than discovering a really exciting, inspirational subject and being able to capture my thoughts and feelings about it in the form of a painting – I think most artists would agree with this. I paint almost every day: painting is something that has been a vital part of my life since childhood and the desire to do it remains as strong as ever. The reason I paint is partly, of course, to fulfil a need, a necessity, and for my own satisfaction and reward. Equally it is to share what I see and feel with others, especially when this concerns a new aspect of an old subject matter or a new discovery.

Evening Study, Place
Del Pi, Barcelona

OIL ON PREPARED BOARD

25.5 x 18cm (10 x 7in)

With its striking contrasts of shape, scale, tone and colour, here was a subject that I simply could not miss!

Painting is a wonderful form of self-expression, but to paint well – and thus create works that are meaningful and have real impact – requires integrity and originality. You have to be true to yourself. Each artist has a different view of the world and this should be reflected in the way that the individual paints, so that there is a personal observation and insight concerning the subject matter, combined with aspects that reveal something about the particular artist. The most interesting and effective paintings are those that are subjective and individual, rather than those that follow a prescribed style or method and could have been made by anyone.

Motivation and inspiration

Inspiration is an instinctive quality, a motivating force and an essential factor in every painting project. Working without inspiration almost inevitably leads to rather ordinary, unexciting results. Ideally, what is required in each new subject is something compelling and different that urges us to paint it. This could be a certain effect of light, an unusual and dramatic composition, or some other feature that makes the subject interesting, distinct and appealing.

However, inspiration isn't just a matter of waiting for something to strike out of the blue. Like so many aspects of painting, it is enhanced by experience. A key skill is being able to recognize the potential of a subject when you stand in front of it. With experience you become a sort of visual detective, able to assess very quickly any qualities within the subject that will translate effectively into a painting. Moreover, sometimes, again because of

Boatyard, Ardfern, Argyll
WATERCOLOUR ON ARCHES ROUGH
39 x 57cm (15¼ x 22½in)

❝ *Dynamic composition is always an attraction for me, so what could be better than a view like this, found by chance when I was looking around a boatyard.* ❞

Winter Morning, Las Ramblas, Barcelona

OIL ON PREPARED BOARD

25.5 x 30.5cm (10 x 12in)

> *I decided on a low viewpoint for this subject, to create the most drama from the height of the plane trees and the canopies of the umbrellas cutting into the light.*

the skills and experience you have built up, you instinctively recognize that the subject, although not inspiring at that moment, would be more impressive if you were to return at a another time of day or in different lighting conditions.

This was my thinking when I came across the scene at Las Ramblas, Barcelona late one afternoon. I could see that it had great potential for a *plein-air* oil painting to capture the busy activity and special mood of the place, but I judged it would work far better in the early morning light. So I returned the next morning and set out to achieve what I had in mind, as you can see in *Winter Morning, Las Ramblas, Barcelona* (above).

Luck can also play a part. Sometimes you just happen to be in the right place at the right time, as I was when I visited the boatyard at Ardfern; see *Boatyard, Ardfern, Argyl* (opposite). As soon as I saw the three boats aligned in that dramatic way, creating such a striking, dynamic composition, I knew that this was something I must paint. There are days that aren't so rewarding, of course, and you return home disappointed. However, the great finds more than compensate for this.

The challenge of painting

In my view, the important qualities to strive for in a painting are a sense of immediacy, event, dynamism, light and drama; conveying the spirit of the place or subject; and an assured touch – by which I mean using brushwork that is expressive and full of feeling, rather than safe and consequently perhaps overworked. When parts of a painting are brushed out to give a smooth finish, they 'die'; in other words they lose the vigour of the raw stroke and the sense of paint. In the work of most painters you will notice quiet areas, unsure passages, along with elements that are expressed extremely confidently and give the painting real impact. There is a little bit of angst, together with some success and technical adroitness, and this makes the painting all the more interesting.

It is seldom possible to produce a painting that successfully combines all the qualities described above: painting is never that easy. However, there are occasions when, inspired by the subject matter and given the right conditions and frame of mind, everything seems to fall into place. For example, in *Steep Hill, Robin Hood's Bay* (page 14), I relished the potential that the subject offered for a dramatic, interesting foreground to lead the eye into the scene. With the particular viewpoint and exaggerated perspective, this gave the painting a terrific sense of design. As well, having been painted on the spot, the work has a strong sense of immediacy, lively brushwork and a sensitive expression of light and mood – something that I hope is the hallmark of all my work. In terms of utter on-the-day satisfaction, it doesn't get much better than that!

The challenge of painting also has much to do with qualities such as determination, perseverance and confidence. Artists generally work alone and it can take a lot of self-assurance to stay motivated. Of course there are periods of self-doubt, even if, like me, you have been painting for over 40 years. While gaining experience and mastering skills are essential factors in developing confidence and success, it is important to remember that everyone has an 'off' day now and then.

Steep Hill, Robin Hood's Bay

OIL ON CANVAS BOARD

56 x 46cm (22 x 16in)

❝ *With its terrific sense of design and exaggerated perspective, this was a very challenging plein-air subject, but an immensely rewarding one!* ❞

Varied influences

There are various factors that help determine our philosophy and technique in painting and, inevitably, one of the most influential of these is our personality. For example, a cautious person is likely to be careful and precise in approach, whereas a more extrovert character will probably work in a freer, expressive way. However, personality is not always an overriding influence, for other factors, such as the artists whom we particularly enjoy and study, or perhaps other artists with whom we paint on location or holiday painting trips, can equally play a part. Certainly for me, developing an initial grounding and experience in painting owed much to the encouragement of several leading artists around at the time when I was beginning to paint, who generously shared their skills and knowledge with me.

An Embrace on the Beach, Sandsend
OIL ON CANVAS BOARD
40.5 x 51cm (16 x 20in)

If well placed and not overstated, figures will invariably add to the interest and impact of a painting.

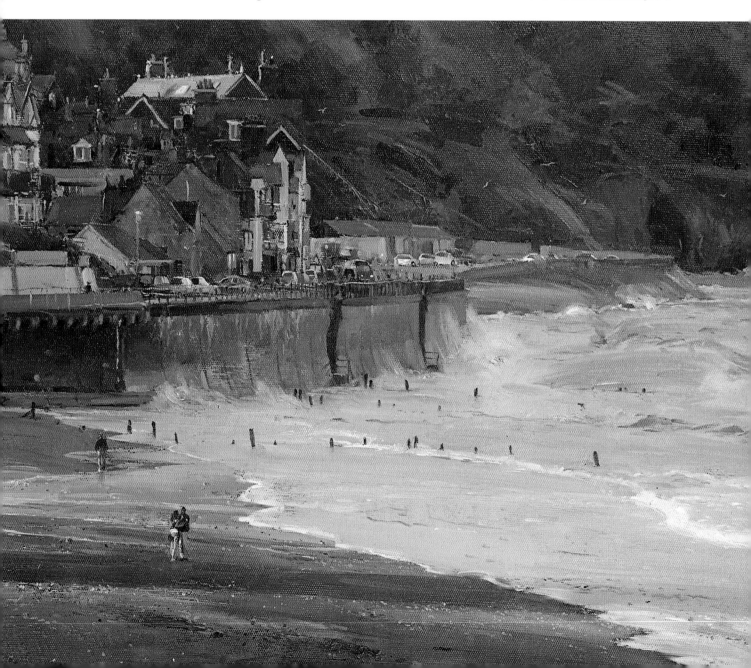

John Burley's Yard, 1964

WATERCOLOUR ON BOCKINGFORD NOT

39 x 57cm (15¼ x 22½in)

❝ This is one of my early watercolours, which, although not as confident and fluent as my present work, nevertheless shows the importance that I have always attached to a composition based on sound drawing. ❞

Working alongside skilled professional artists is one of the best methods of learning the basic craft of painting. Nevertheless, while we can learn a great deal from other artists, ultimately our success will depend entirely on ourselves – our degree of commitment to practice, persevere, experiment and so on. Enthusiasm – a love of painting – is perhaps the most essential quality, particularly if it is matched by dedication.

It is worth a reminder at this point that painting is not just about technique; it is equally a way of seeing and interpreting. The ability to observe, understand and concentrate on the essentials of a subject is a vital asset, as are drawing skills. Always, the impact of a painting will rely just as much on sound drawing, keen observation and interesting content and design, as it does on the handling of paint and use of colour. All these aspects need constant practice. For instance, I have often both attended and taught life classes over the years: life drawing is an invaluable discipline, I think, not just for figure work but also for developing drawing skills in general.

Practical issues

I paint on the spot whenever I can and inevitably such paintings are influenced by various practical issues – a limitation of time or viewpoint, for example, or the changeable effects of light and weather. These issues have to be addressed and, in my experience, there are two key factors that will contribute to a successful outcome: first, it is wise to start with an assessment of the situation, so that you can fully appreciate and exploit the strengths of the subject matter and conditions; and additionally, you must be prepared to make quick decisions as the painting develops.

Bubion, Las Alpujarras Mountains
WATERCOLOUR ON PAPER FROM A SAUNDERS
WATERFORD WATERCOLOUR BLOCK
30.5 x 40.5cm (12 x 16in)

"Often, compromises have to be made when painting outside. Although I had to work from the side of a car park for this subject, nevertheless it made a very interesting, atmospheric painting."

With *Bubion, Las Alpujarras Mountains* (above), for example, I was struck by the beauty and atmosphere of the scene, but my viewpoint was governed by the fact that I had to work from the side of a car park. This meant that the foreground was largely taken up by several flat-roofed rectangular buildings, which initially were a concern. After some deliberation, I decided that the simplicity and restfulness of the buildings – in terms of their colour and the limited amount of detail – would create a useful contrast to the background, with its impressive mountainous slopes and dramatic sense of scale and distance. In fact, I thought the final painting worked quite well, particularly regarding my decision to use watercolour, which was perfect for capturing the contrasts of light and the distant heat-haze effect.

With this example, as is sometimes the case when painting outside, the viewpoint from which I was able to work was a compromise between what was ideal and what was possible and safe. Nevertheless, because the composition of the painting is always important to me, I will often go to extraordinary lengths to find the best viewpoint and, as a result, this may mean working from a very awkward, uncomfortable position. On the other hand there are times when, perhaps because of an impending change in the weather, a lack of time, or the overall activity and busyness of the place, I cannot work from the viewpoint that I would like. Therefore the only option is to make some quick notes or sketches, or take photographs.

One of the most difficult aspects of working on site is when conditions change radically during the painting process. This is when you have to make some important, quick decisions. It depends on the circumstances and how much progress you have made with the painting, but generally the best approach is to keep to your original intentions for the work, especially regarding the overall mood and light effects. There is no benefit in trying to keep up with the changes of light as the sun appears and disappears. However, there are times when something alters to the advantage of the subject matter

Last Snow and Bright Sun,
Mitchelfield Farm, Hathersage

OIL ON PREPARED BOARD

25.5 x 30.5cm (10 x 12in)

" *Particularly in winter, it is a tremendous advantage to be able to work quickly and decisively for* plein-air *paintings. Generally, the first 15 minutes are the most crucial.* "

and in consequence is worth adding to the painting. For example, a passer-by might stop for a few minutes in just the right place for you to include them as a point of interest in the painting.

Undoubtedly it is a tremendous advantage to be able to work decisively and quickly for *plein-air* paintings and sketches. In my experience, the first 15 minutes are the most crucial, when you will have the most enthusiasm for the idea. After that the light may start to change or other factors may come into play, which begin to make the work more difficult, so you need to capture the essence of the subject as quickly as possible. Another asset is a good memory – the ability to recall useful reference information at a later date in the studio – and so enrich the paintings you are working on.

Self-expression

Although my paintings are based on fact – working from observation – the emphasis is always on making a personal response rather than feeling that I must accurately depict every facet and detail. Self-expression is fundamental to painting: I can see little point in simply making a record of what is there, expressed without any feeling or individuality. Moreover, painting is about communicating ideas. In my paintings I hope to involve the viewer in the excitement I had for the subject and the qualities that I felt were important about it, together with my way of interpreting shapes, tones and colours.

In painting a subject and producing a result that has impact, there is usually a need to select, simplify or exaggerate various elements. Few subjects are heaven-sent and therefore you have to make the most of what is there –

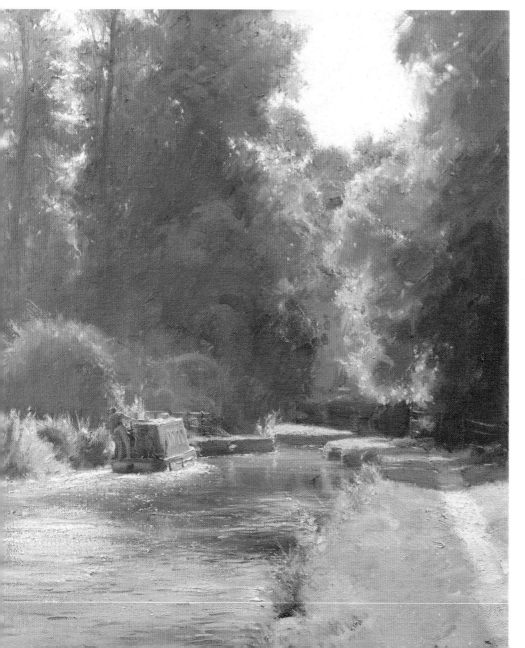

The Narrow Manoeuvre

OIL ON LINEN CANVAS

61 x 51cm (24 x 20in)

" *I captured this subject just as the narrowboat was arriving, thus turning a rather ordinary scene into something much more exciting.* "

to turn the ordinary into the extraordinary. For example, for my painting of *The Narrow Manoeuvre* (opposite), I happened to be on site at exactly the right time to witness the arrival of the narrowboat, which provided the extra ingredient that the scene needed. Despite that stroke of luck I still needed to enhance some elements of the composition to make the painting work more effectively. I lowered the horizon and stretched the trees to make them look really majestic, which in turn gave the composition more vigour and interest.

For me, self-expression starts with observation and initially I concentrate on the key shapes that will make up the composition. This involves an assessment of the middle and distant shapes just as much as the foreground. There has to be strength in the forms throughout the composition – rather than an imbalance created by too much emphasis on the foreground – plus the necessary interpretation of space and depth achieved through the sensitive use of colour, tone and paint handling. Related to this, features such as trees must be resolved satisfactorily, so that branches feather-off, for example, and the form and texture of the tree is convincing and has an inherent poetry.

Original ideas

Ideally each artist should work in a way that is distinctly theirs and is not too influenced by other painters or art movements. However, while it is good to have your own style, it must never be at the expense of allowing some freedom in your work. My advice is to risk a little experimentation from time to time, whether in technique or subject matter, as this will help keep your paintings lively, interesting and challenging. Moreover, style is not something that is necessarily fixed for the rest of your career. If you are serious about your work and always seeking to improve your painting skills, then inevitably your style will gradually change.

**Thatched Barn,
High Easter, Essex**

WATERCOLOUR ON BOCKINGFORD NOT

39 x 57cm (15¼ x 22½in)

❝ *Another early, large watercolour painted on site and showing the more daring approach and raw energy of youth.* ❞

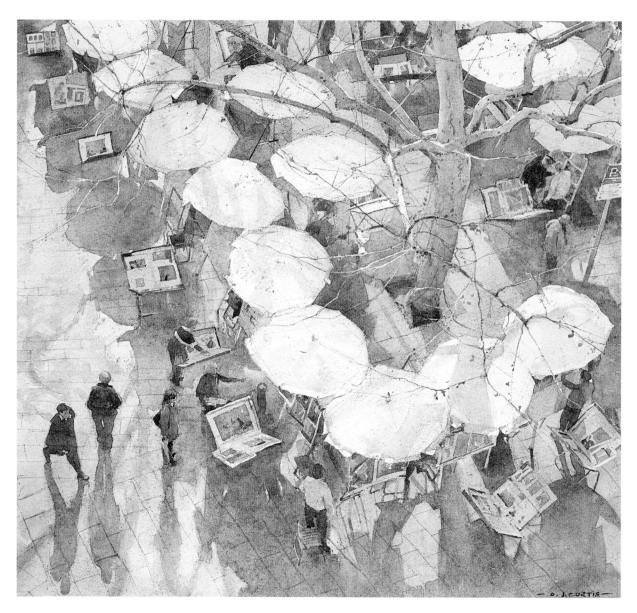

Sunday Art Market, Barcelona
WATERCOLOUR ON ARCHES ROUGH
39 x 43cm (15¼ x 17in)

" *I loved the sense of rhythm and extraordinary perspective in this subject, which I painted from a balcony high above.* "

There have certainly been differences in my style over the 40-year period of my painting career. Note the raw energy evident in *Thatched Barn, High Easter, Essex* (page 21), for example, painted when I was quite young. Compare this with the much more considered approach shown in *Sunday Art Market, Barcelona* (above), which is a recent painting. In this painting the design is far more sophisticated and exciting, as is the use of the subtle washes and lost and found edges.

I now have a far greater range of techniques at my command and a much wider experience of different types of subject matter, enabling me to paint in a more varied way. I hope, for instance, that as you look through the illustrations in this book you recognize certain characteristics of my style but, because of the variety of approaches and ideas, you are not always sure! The advantage of this sort of versatility, particularly if it applies to more than one medium, is that you are in a much stronger position to interpret ideas as effectively as possible.

Old Glory and the Bandstand, Whitby Harbour

WATERCOLOUR ON PAPER FROM A SAUNDERS WATERFORD WATERCOLOUR BLOCK

30.5 x 40.5cm (12 x 16in)

" As here, when the subject is more complex, I do what I can on site and then complete the painting in the studio, working from reference notes and photographs. "

Medium, technique and expression

Obviously the success and impact of a painting is also greatly influenced by the choice of medium, support and techniques. Look at *Old Glory and the Bandstand, Whitby Harbour* (above), for example, which was painted on paper from a Saunders Waterford block, and compare the result with *Sunday Art Market, Barcelona* (opposite), for which I used a sheet of Arches Rough. These are completely different surfaces and each has a significant impact on the techniques and effects that are possible. The Arches paper is thick and robust. Its textural surface will hold generous washes, take many superimposed layers of colour and stand up to techniques such as lifting out, without any obvious damage to the surface. Also, it is ideal for large-scale studio work.

In contrast, the Saunders Waterford block requires a more restrained approach relying on very gentle washes, rather similar to the Victorian style of watercolour painting. This paper is often the better choice for location work, for which there is usually a limited timescale and the need to work quickly with single, uncomplicated washes of colour. There is no need to stretch this paper, but I do stretch the Arches sheets drum tight, even the very small sheets, which is something else that can influence process and technique.

Similarly, when I paint in oils, I generally choose a linen canvas for a large studio work or for a subject where I want the brushmarks to play a key part, while alternatively, for location paintings, I normally work on a prepared gesso board or canvas board. Whatever the medium, I always use the best quality paints and other materials.

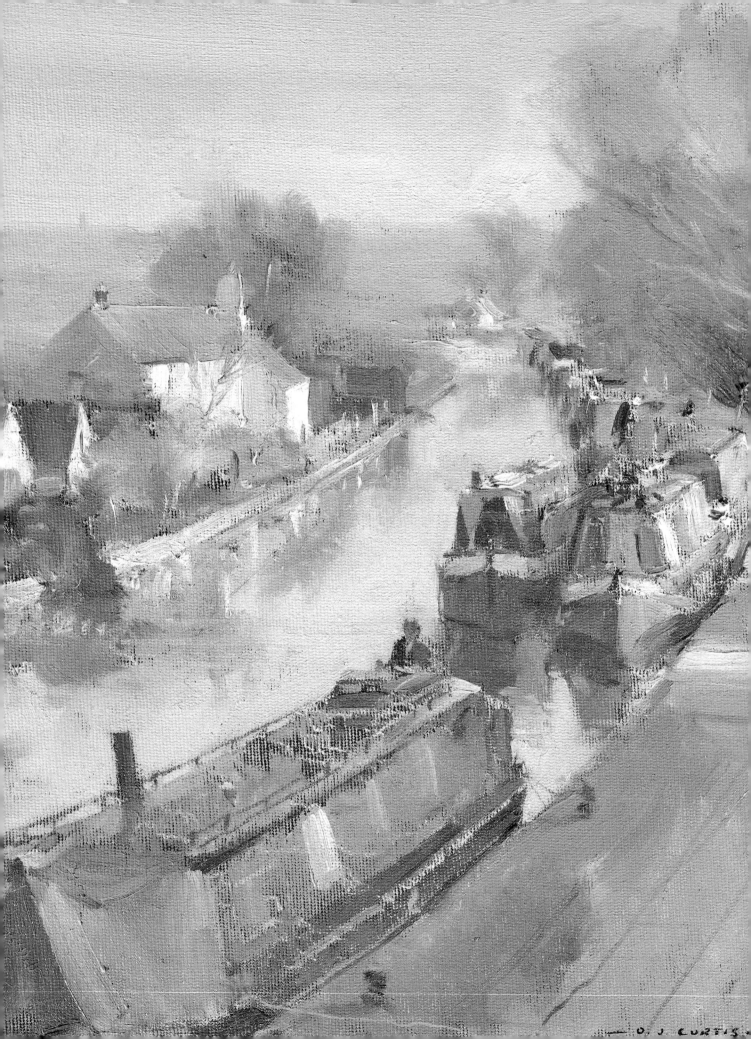

O. J. CURTIS.

Building on success

Most artists work on the basis that their best painting 'will be the next one'! This is a cliché perhaps, but it is nevertheless a good philosophy and motivating force to believe in. To set increasingly greater challenges in our work, and always be striving for results that are visually more exciting and show improved technique, is obviously a sound approach. Additionally, patience and perseverance are necessary qualities because, although we will hopefully learn something from every painting, inevitably the rate of improvement is a very gradual process.

However, one of the exciting things about painting is that now and again, quite unexpectedly, something happens that is really enlightening and in consequence lifts our work to a new level. It could be something to do with technique, the way that a particular quality of effect in the subject matter is interpreted, or perhaps a different approach in the use of colour. This sort of coincidental discovery in a painting can have a significant influence on the subsequent direction and development of our work.

Equally, there are occasions when a painting forces you to act boldly and completely out of character in order to save it from disaster. I can remember once struggling and becoming very frustrated with a watercolour painting on a sheet of tinted paper, because the surface was reacting rather like blotting paper, presumably because it had been inadequately sized. Although the absorbent surface proved ideal for the soft background effects that I wanted, it was hopeless for the strong colour necessary in the foreground area, so I took the unusual step, for me, of working with body colour (watercolour mixed with white gouache). It was a gamble, but it succeeded, and I managed to re-establish the strength and definition of colour that I needed.

Success breeds confidence and this in turn encourages a more adventurous approach, with paintings that are more interesting and rewarding. Also, of course, we can learn from our mistakes – and incidentally even the most experienced artists have the occasional failure! Sometimes it is quite obvious what has gone wrong with a painting and which colour, technique or process should have been used instead. At other times the mistake itself teaches us something about a particular medium or technique. The main thing is to persevere with your paintings and accept that not everything will succeed, especially if you are true to your feelings and not afraid to test your abilities to the limit.

Midwinter Moorings

OIL ON PREPARED BOARD

30.5 x 25.5cm (12 x 10in)

" I liked the flow of the design here, with its essentially triangular composition and repeated triangular shapes. "

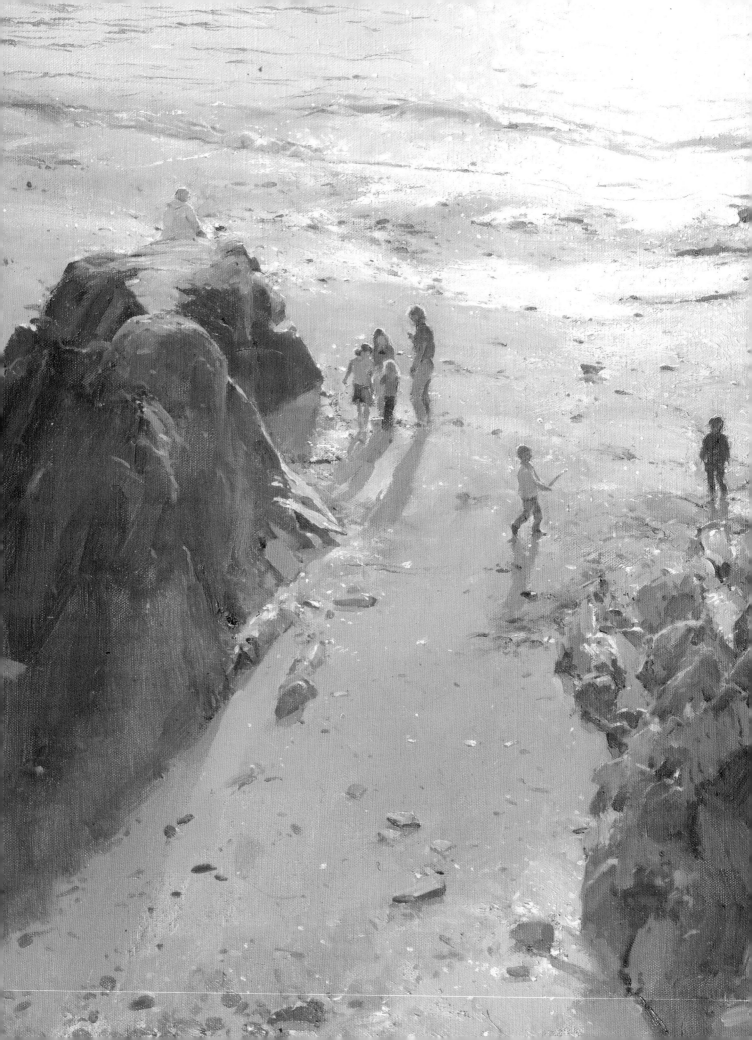

PICTURE PROFILE
Evening Light, Peel Harbour, Isle of Man

Here is an oil painting that relates to all the key aspects and challenges of painting discussed in this section. It was inspired by a wonderful low-lit scene that I came across one afternoon during my first visit to the Isle of Man. There are some stunning beaches on the Isle of Man and, certainly during this trip, the quality of the light was exceptional. By choosing a high vantage point from which to paint the scene, I was able to make the most of the drama of the light and also create a composition that had dynamism and originality.

In a way, this was a simple subject, but nonetheless one that involved an interesting variety of features and qualities. For example, there was a distinct contrast in the tone and structure of the two separate rock formations, requiring some subtlety in the dark areas and different painting techniques. In many of my paintings I like a high horizon with a limited amount of sky or, as here, no sky at all, although this can make the interpretation of space and depth more difficult. As I often do, I have relied on the use of tone to convey recession, working from stronger tones in the foreground towards the brilliantly lit sea area.

I found this subject late in the day, having earlier completed a painting of a view across Peel Harbour. I made a small oil study on site, working on a 25.5 x 30.5cm (10 x 12in) prepared gesso-coated board, and subsequently used this information as the basis for the larger studio painting shown here. Often when I am out painting I find that the best work is produced at the end of the day. I think as the day goes on I become more reflective and attuned to what is around me. This said, I do not usually have to spend very long in a new location before I am eager to start painting – and this was certainly true of the Isle of Man.

Evening Light, Peel Harbour, Isle of Man

OIL ON LINEN CANVAS

61 x 76cm (24 x 30in)

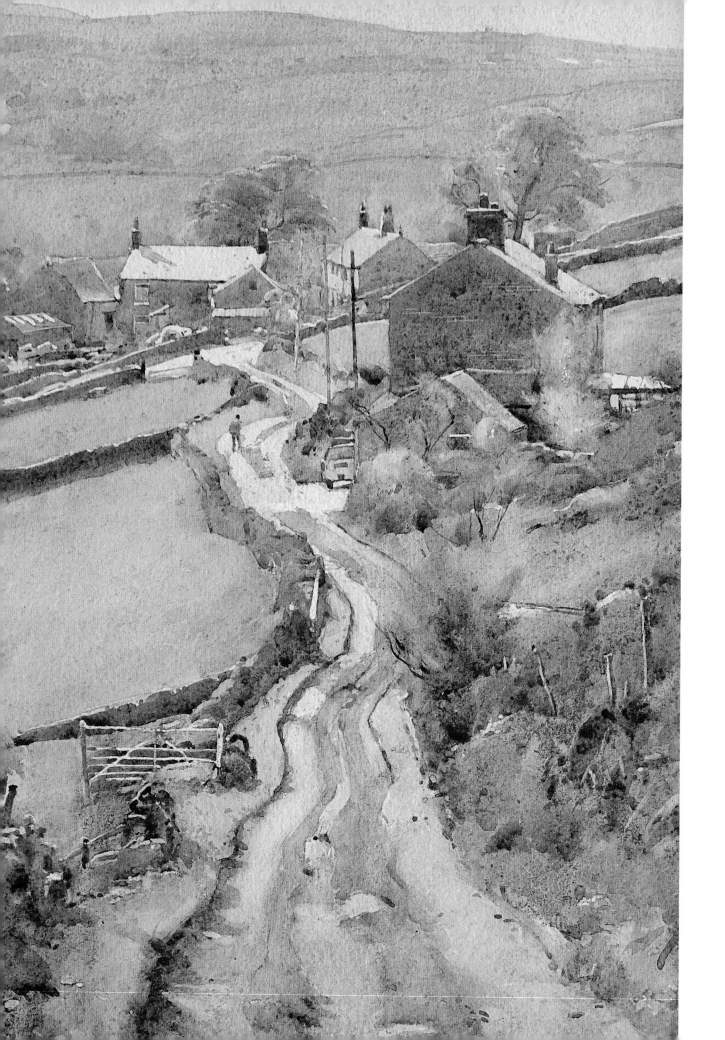

Key Elements

2

I started painting on a regular basis in my early teens and almost from the beginning, encouraged by the example of some very experienced local artists, I adopted a practice for assessing the key elements of a subject, known as the 'factor of three'. The three elements were appeal, composition and tone. The idea was that by considering each of these within a painting subject you could judge its worth, both in terms of its possibilities as an interesting painting and, ultimately, the painting's potential for exhibition and selling. Then, as now, all of my work was inspired by *plein-air* subjects and I found the 'factor of three' method of evaluating them both helpful and reliable. I still use it today.

**Winding Lane
above Holmfirth**

WATERCOLOUR ON ARCHES ROUGH

38.5 x 28.5cm (11 x 15in)

" *For me, the three key elements to look for in a subject are appeal, dynamic composition, and interesting tonal contrasts.* "

Appeal

Because I am a tonal painter who prefers to work outside whenever possible, usually the aspect that I find most exciting and appealing in a subject is the particular quality of light and how this influences the mood and impact of the scene. My preferred approach is to paint *contre-jour* (into the light), so that the tonal effects are enhanced, although recently I have been working more often with the light behind me, which consequently creates greater emphasis on colour. Often, the subjects that have most appeal are those that I find during the early morning or late afternoon on a bright, sunny day when there are strong contrasts of light and shadows.

While a stunning light effect will add drama and impact to the subject matter, it must nevertheless work in relation to certain other factors if the proposed painting is to be a success. The content, and in particular the principal shapes within it, are equally important aspects to consider. Those main shapes will provide the basic structure for the painting and ideally not only must they instil a degree of energy and excitement in the design, they must also be carefully observed and well drawn. Look at the wonderful cliff shapes in *Cliffs and Beachscape, Porthcothan, Cornwall* (opposite), for example. Note also in this subject how the strong, low light creates interest and variety in the tones, with areas of mystery contrasting with others that are more clearly defined.

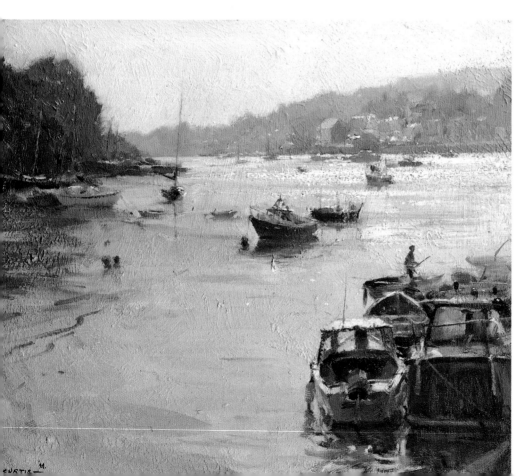

Penryn Harbour, Cornwall

OIL ON BOARD

25.5 x 30.5cm (10 x 12in)

❝ *Here, the appeal was the moody, atmospheric and diffused quality of light.* ❞

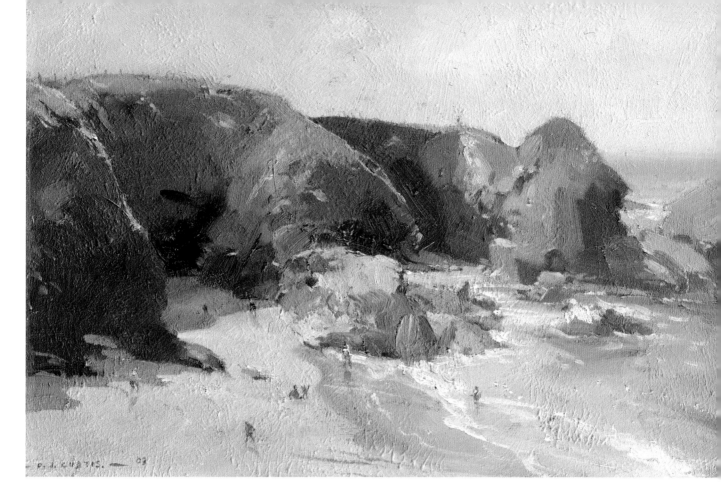

First reactions

Cliffs and Beachscape,
Porthcothan, Cornwall

OIL ON BOARD

20.5 x 30.5cm (8 x 12in)

" To paint convincingly relies on an understanding of the subject matter, which in turn begins with observation – by studying the cliff formations in this subject, for example. "

The initial reaction to a subject is important, because if there isn't a sense of excitement about what you see – and a strong desire to paint it – then the eventual painting is unlikely to be a great success. However, before rushing to unpack the paints, it is always a good idea to spend some time making a more considered assessment of the subject. This will help avoid disappointment. When you are enraptured by something truly original and moving within the subject matter, it is easy to overlook a lesser feature that could ultimately prove a serious weakness in the design and impact of the work. Generally speaking, it is best not to be too hasty.

With this type of assessment, the ideal approach lies in striking a balance between relying entirely on inspiration and impulse and being too analytical about what you see and feel. My advice is to base the composition on whatever aspect of the subject matter first attracted you but, through a process of selection and perhaps inventiveness, ensure that the painting as a whole will work in relation to that main focus. Check the principal compositional elements, the colour contrasts and harmonies, and so on. If some kind of adjustment seems necessary in order to reinforce the impact of the main elements, check that it is not simply a matter of altering the viewpoint. Sometimes just a slight modification to the viewpoint will dramatically improve the composition – by just moving to the left or right a little – see *Harbour Activity, Castletown, Isle of Man* (page 32), for example.

Now, with accumulated experience, I find I can make the initial assessment of a subject – its individual strengths, nuances, design and structure – very quickly. With *Harbour Activity, Castletown, Isle of Man* (above), for example, I loved the classic lines of the boat and instinctively felt that the dynamics of the design would be emphasized by painting it from that particular angle. I could see that the boat would make a great composition when viewed with relatively little interest to its left and contained nicely by the variety of shapes on the right. As is so often the case, the light was a factor, creating some lovely strong dark areas that helped emphasize the bold form of the hull and the sense of depth towards the horizon.

Skill and ambition

Ambition is always a good thing. In choosing subject matter and deciding on the approach and techniques to use, my advice is to aim for work that tests

**Harbour Activity,
Castletown, Isle of Man**
WATERCOLOUR ON ARCHES ROUGH
28.5 x 38.5cm (11¼ x 15¼in)

Viewpoint is everything in creating the most drama and impact from a subject.

your ability and involves ideas and methods that are at the edge of, if not slightly beyond, your 'comfort zone'. If the painting places demands on you in this way, it is more likely to succeed as a strong, interesting image. Moreover, you will find that it is only by confronting even greater challenges – and persevering at ways to solve these – that you will improve your work and gain in confidence and skill.

The difficulty lies in judging just how ambitious you should be. By playing safe you gain nothing, whereas if you are over-ambitious the challenge could prove beyond you. It is a matter of finding the right balance. While you are gaining experience, I would say look for subjects that have bold, simple shapes, giving a sound compositional structure, as in *Bridge and Stream, Aberdaron* (below). Here, the main shapes are easily defined and they work well together to create an effective design. It is what I would call a traditional subject and, given the necessary care in the observation and drawing of the principal shapes, it is the type of subject that should prove a reliable and rewarding one to attempt.

In contrast, with a painting such as *Harbour Activity, Castletown, Isle of Man* (opposite), the demand on ability and experience is much higher. As you can see, in that particular subject, irrespective of the technical skills required to master the form of the boat, success depended very much on decisions about viewpoint and content. In fact, to help with those decisions, I started by making a small pencil sketch – just a few lines in a 10 x 5cm (4 x 6in) sketchbook. With more complex subjects, making a sketch is a useful way to help plan the essential elements of the design, even if I also decide to take some photographs.

Bridge and Stream, Aberdaron

OIL ON CANVAS BOARD
40.5 x 51cm (16 x 20in)

❝ This was a lovely, what I would term 'traditional' subject, with lots of foreground interest. ❞

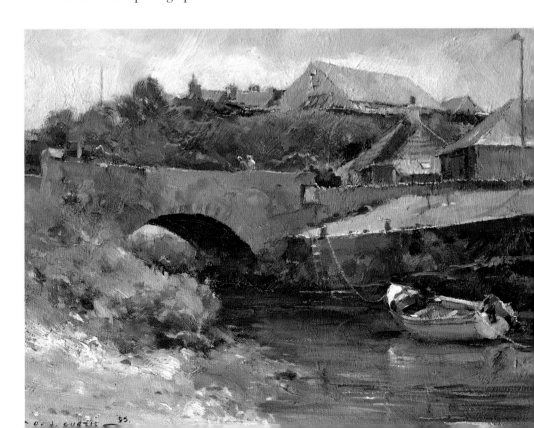

Keeping an open mind

My most popular paintings are my beach scenes but, as you can see from the wide range of illustrations in this book, I enjoy the challenge of different subjects. I do not think it is a good idea to confine yourself to one specialist subject area. As well as being ambitious about how a subject will test your ability in expressing it in a convincing, original way, aim to keep an open mind regarding new types of subject matter.

 I am always on the look out for quirky, challenging subjects. Even when I paint at Staithes in North Yorkshire, which is one of my most familiar painting locations, I try to find new, unexpected views. For me, the more

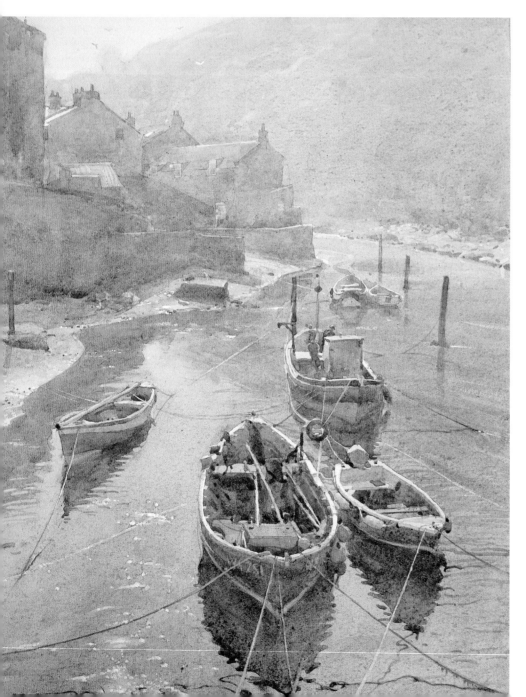

Rising Mist, Staithes Beck

WATERCOLOUR ON TWO RIVERS
TINTED PAPER
38.5 x 28.5cm (15¼ x 11¼in)

" Again, here the inspiration was the mood of the scene. There was a lifting sea fret, creating some wonderful highlights on the boats. "

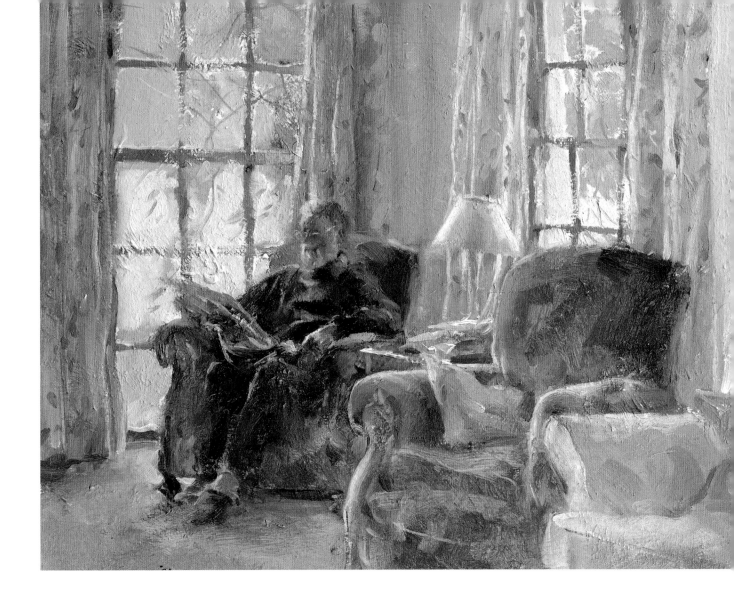

Roland with the Morning Paper, Rahoy Lodge, Scottish Highlands

OIL ON BOARD

25.5 x 30.5cm (10 x 12in)

A wet day kept me inside, but I still found something interesting to paint.

important concern is that the subject will make a good painting, rather than be instantly recognizable as a particular place. Also, of course, light and weather can play their part in influencing the look and mood of a scene. What inspired me to paint *Rising Mist, Staithes Beck* (opposite), for example, was experiencing the scene masked by a heavy sea fret, or fog, which gave it an eerie, almost satanic feel. In fact, just ten minutes before I started painting this subject, it was barely visible. So, essentially the challenge was to capture the dramatic atmospheric quality – it is Staithes, but a different Staithes!

Coincidentally, the weather was also an influential factor when I painted *Roland with the Morning Paper, Rahoy Lodge, Scottish Highlands* (above), which for me was certainly a subject that was different and outside my comfort zone. It was a very wet day, but I desperately wanted to paint. I wandered around the house where I was staying with a group of painting friends and came across Roland reading his newspaper. In some respects this was not the perfect subject, but I was confident I could make something of it. I felt that there was enough interest in the pose of the figure to allow some of the surrounding background area to be treated in a much looser way. Interestingly, the more I worked on this painting, the more rewarding it became.

Composition

Children Playing in the Beck

WATERCOLOUR ON ARCHES ROUGH

38.5 x 28.5cm (15¼ x 11¼in)

❝ With its incredible light effect, figurative content and juxtaposition of shapes, this was one of the most satisfying subjects I have ever painted. ❞

However well something is painted, poor composition will show and will seriously undermine the impact of the work. The potential within the subject matter for an exciting, successful composition is of paramount importance. Equally it is essential that the composition is carefully planned to support the aims of the work and ensure that the interest is kept within the bounds of the picture plane. I look for a composition that has a strong, well-balanced arrangement of shapes, without any sense of awkwardness. I like the composition to include something that leads the eye into the painting and takes it on a journey to a focal point, which is often a figure or group of figures involved in some sort of activity.

I think *Children Playing in the Beck* (opposite) has one of the most satisfying compositions I have ever painted. I chose this subject for a painting demonstration that I had agreed to give at the Royal Society of Marine Artists exhibition at the Mall Galleries in London. I remember saying to the assembled group of 100 people that I was not too worried about working on the painting because the composition was so stunning and would compensate should there be any lapses in technique on my part. I decided to use a portrait format, which I felt would make the most of the dynamic play of shapes and the wonderful contrasts of light and shade. You can see that I have included a 'lead-in' with the foreground boat, active figures as a focal point and a small section of the red wall on the left to act as a 'stopper' to contain the interest within the painting.

In contrast, *Old Church by a Dusty Road, Mykonos, Greece* (below), a small *plein-air* oil painting, required a different sort of skill and inventiveness to

Old Church by a Dusty Road, Mykonos, Greece

OIL ON BOARD

25.5 x 35.5cm (10 x 14in)

❝ Sometimes a certain amount of manoeuvring with shapes and tones is necessary to create the most impact with a subject. Here, for example, to ensure a more balanced composition I invented the man on the scooter and exaggerated the tonal contrast. ❞

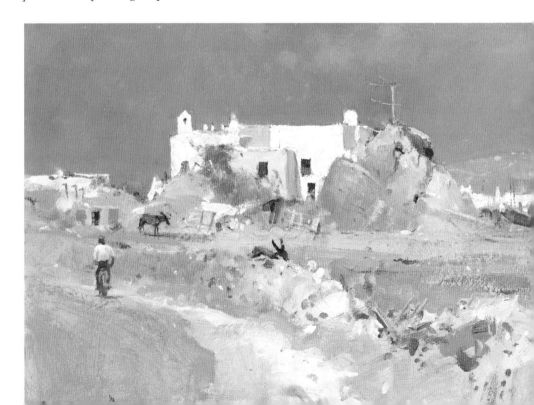

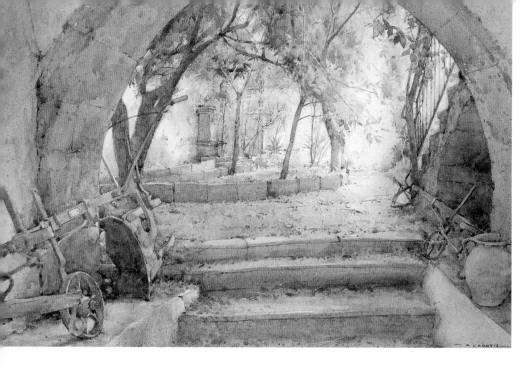

overcome the challenges of its mostly ill-defined shapes, particularly in the
large foreground area. For example, the rough roadway could easily have
drifted out of the painting to the left, which is why I decided to invent the
man on the scooter. The donkeys were part of the scene, although I moved
their positions to help enhance a sense of depth across the foreground and
similarly I exaggerated some of the tones, especially on the lower-right area,
to ensure a more balanced composition.

Bold design

Often, in the early stages of learning to paint, there is a temptation to think
that you must include every detail of the subject matter, as seen. In fact, very
fussy, detailed paintings are seldom as effective as those in which the artist has
selected and simplified certain elements in order to create a better sense of
harmony and visual impact. The basis of good composition lies in the ability
to focus on those aspects of the subject matter that are essential to the
dynamics and interest of the design and, equally, knowing which aspects
to subdue or perhaps ignore altogether. Success relies on economy of means,
so that the composition conveys a great deal – both in terms of content and
feeling – yet at the same time leaves something to the viewer's imagination.

There are plenty of theories about composition, with advice as to what
you should and should not do. Such theories are worth consideration, but
a composition that relies heavily on theories will usually look contrived and
consequently not attain its full impact. Most experienced artists work with
a knowledge of the theories but at the same time they adopt a more intuitive
approach. What seems right in theory doesn't always succeed in practice and,
conversely, with experience and ingenuity, something about composition that
should theoretically be avoided can be made to work effectively.

**Riverside Mooring,
Bosa, Sardinia**

WATERCOLOUR ON ARCHES ROUGH

28.5 x 38.5cm (11¼ x 15¼in)

"Here, the accent was on strong vertical and horizontal elements in the design."

Generally, compositions based on a symmetrical or evenly balanced arrangement of shapes are not very successful. For this reason, most artists avoid placing something directly in the centre of the picture area. I sometimes include a feature that is almost central but not quite, as with the mast in *Riverside Mooring, Bosa, Sardinia* (above), The position of the mast works in this composition, partly because it is not a dominant feature and also because it links in well with the essential vertical and horizontal structure of the painting. Incidentally, note how the rigidity of the design is countered by the play of light and shadows.

As well as the relative positioning of the main shapes, well-conceived directional lines are often important as a means of creating a flow or a sense of rhythm around the painting, which can be reinforced by repeating little passages and accents of the same colour. Also, the energy and interest within the design can be enhanced by contrasting bold shapes and tones with some areas that are handled in a more impressionistic manner.

With most compositions I am seeking to tempt the eye into the central area of the painting, leaving the edges and corners less resolved, but I never rely on a set format. In *Above Beck Hole* (page 40), for example, the composition has a strong, diagonal rhythm. Similarly in *Rising Mist, Staithes Beck* (page 34), the angle and placing of the foreground shapes combine to create a dramatic lead-in to the painting and a sense of recession. Z-shape and S-shape designs are also effective in this way. In other paintings I rely on the more traditional 'rule of thirds' principle. Based on the Golden Section, this is a reliable form of composition built around a key shape placed approximately one-third of the way across the picture area.

Key Elements **39**

D. J. CURTIS

Associated design factors

Above Beck Hole

OIL ON BOARD

35.5 x 25.5cm (14 x 10in)

For the composition in this painting, I exploited the inherent diagonal rhythm of the subject.

Together with due consideration to the selection and arrangement of the key shapes within the composition, its impact can be enhanced by the particular way that other aspects are treated during the painting process, such as contrasts of light and dark, the use of colour and texture, and the handling of foreground areas. For instance, as well as being an essential element in expressing the mood of a subject, shadows can contribute in a very positive way to the visual flow, energy and interest in a painting. As you can see in *Ancient Woodland, King's Wood, Bawtry* (below), they can be especially helpful in a foreground area, both as a means of dividing up and adding interest to an otherwise uneventful space and as a way of creating a lead-in to the painting.

In fact, in this painting I deliberately emphasized the simplicity of the foreground as a restful area, in contrast to the busy pattern of dappled light and shade that fills the top half of the composition. It is essentially a painting about light and shade, although this would not have been sufficient in itself to create a strong composition – I felt it needed the two, almost centrally placed figures to add a focus and an extra bit of interest and impact. Similar points apply to the use of reflections, as in the foreground area of *Old Moored Vessels on the River Orwell* (page 42). Here, note how the masts and their reflections break the composition quite boldly into three areas, but with the strong verticals countered by the shapes and angles of the hulls.

Colour is another useful means of giving emphasis to certain parts of the design and acting as a linking device. Although I am not a colourist, I quite often include a passage of high-key colour as a striking contrast or focus

Ancient Woodland, King's Wood, Bawtry

OIL ON BOARD

40.5 x 30.5cm (16 x 12in)

Shadows are often a very effective way of linking parts of a composition, as here.

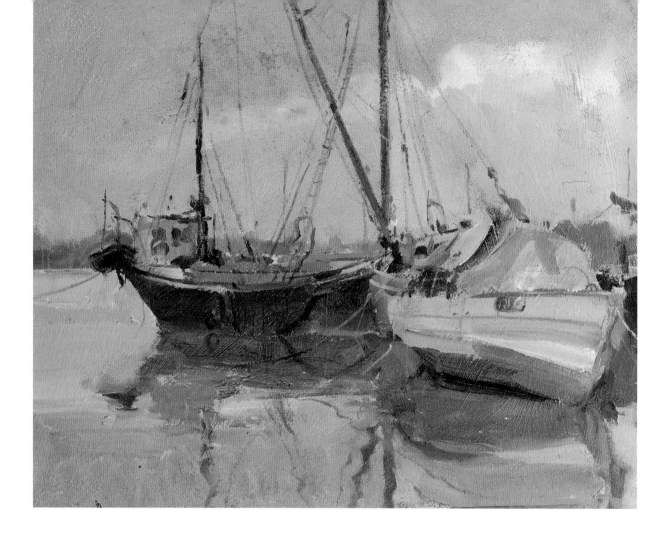

somewhere within the composition, which is another effective way of strengthening the impact. The considered use of more vibrant colour, as with the bands of burnt sienna on the boats in *Old Moored Vessels on the River Orwell*, will enliven a modest subject. Note too in this painting how echoes of a particular colour (burnt sienna) will help unify the design.

Tone

As I have mentioned, usually it is a particular quality of light that I most want to capture in my paintings and, therefore, I work principally in terms of tone. The inherent tonal qualities of the subject matter (that is the relative lightness or darkness of each particular element), and the potential to exploit these to create a painting with real impact, are aspects that I consider right from the start. In fact, the tonal key is often the feature that initially inspires me to paint something and, certainly more than other aspects such as composition, it allows a fair degree of freedom in the way that it is interpreted. The tonal balance, variety and impact are not always perfect as found in the subject matter but, with experience, these properties can be modified or exaggerated as necessary in order to enhance the success of the painting.

**Old Moored Vessels
on the River Orwell**
OIL ON BOARD
25.5 x 30.5cm (10 x 12in)

Like shadows, reflections will add interest to otherwise uneventful areas of a painting.

Drama and content

In some ways a sunlit, late afternoon subject will be easier to paint because the contrasts between highlights and deep shadows will be more evident and immediately add to the drama and mood of the scene. As in *Tenders on the Slipway* (below), it is often the play between the intense dark areas and the much lighter areas that contributes most to the energy and interest in the painting. Naturally I enjoy painting subjects in which there is an obviously strong light effect, but equally I like to paint in all types of light, including flat light – the sort of low, even light experienced on a dull day. Flat light can be just as rewarding, I think, and as I have implied, there is always the option of exaggerating the slight variations of tone that you find.

Old Moored Vessels on the River Orwell (opposite) was painted on a very dull day, but as you can see, there is no lack of tonal contrast. I was struck by the potential in the composition of this subject and felt that it would work very well if I could somehow extract more drama from the tonal values. So, it was a matter of making the most of what was there and exaggerating the tonal range to significantly strengthen the darks and intensify the lightest areas. In fact, there can be an advantage in painting in flat light, because it will remain fairly consistent over a longer period of time and thus, if you wish, there is a greater opportunity to concentrate on the drawing and detail in the subject matter. For example, this is the sort of light I prefer for painting barn interiors, boatyard workshops and architectural subjects, which rely more than most on sound drawing.

Tenders on the Slipway

OIL ON BOARD

30.5 x 40.5cm (12 x 16in)

❛❛ I always make the most of the tonal contrasts in a subject, as this will enhance its impact. ❜❜

Light is a transient quality and one of the difficulties when working outside is that the weather, and consequently the light effect, can change considerably during the course of the painting. Even on a fine summer's day clouds and shadows can come and go. Because of this, it is wise to establish as quickly as possible the type of light effect and mood that you want for the painting. Keep that in mind and do not be deterred if conditions change. Some artists like to start with a quick, small tonal sketch to use as a reference. Also, bear in mind that the same subject will result in quite a different painting at another time of the day or in different weather conditions. So, if the composition is enticing but the lighting is poor, an alternative approach is to return when you calculate that everything will be just right.

Tone and colour

In capturing the mood of a scene and the sense of place, the ability to assess tonal values and interpret them convincingly is a vital asset. Yet the concept of tone, as opposed to colour, can be a difficult one to master. In fact, tone and colour are inseparable qualities, for each colour, as well as being yellow, blue or whatever, also has a particular tonal (light/dark) value. Tone relates to colour in two ways: each colour has an inherent tonal quality, so that yellow, for example, is a naturally light-toned colour and Prussian blue a dark one. Irrespective of this, within each colour there can be many variations of tone, according to how much it is diluted or which other colours it is mixed with.

When painting, the subject matter may include elements of local colour – that is the actual colour of the object, unaffected by shadows or reflections from surrounding objects – but usually the colour and its consequent tonal values are influenced by the effect of light and the way that it plays across a surface. Sometimes this creates many tonal variations, even within a relatively

Copse on a Hillside, Anglesey
OIL ON BOARD
23 x 30.5cm (9 x 12in)

❝ *To convey the calm mood of this scene, I used a limited palette of harmonious greens, blues and greys.* ❞

I love the challenge of busy scenes like this, which fully test one's skills in drawing and the use of colour.

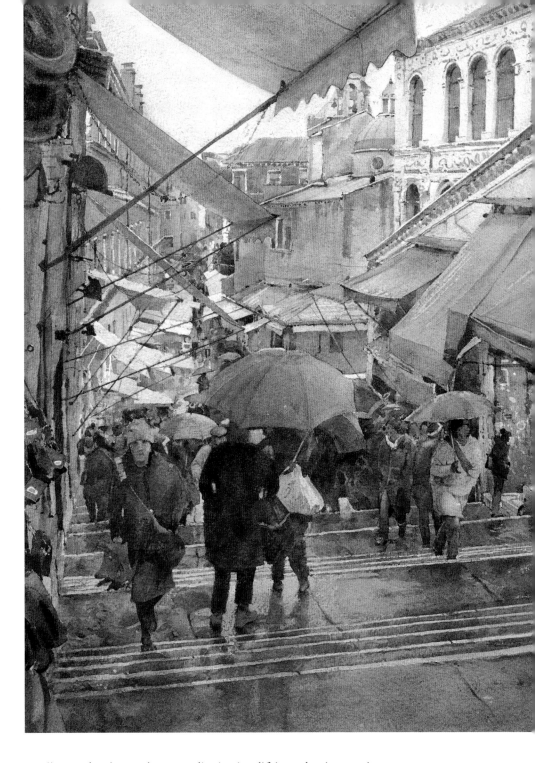

small area. As always the secret lies in simplifying what is seen; in concentrating on the essence rather than every detail. If you squint at the subject it helps to give a better perception of tone rather than colour, with a simplified view of the tonal range and the contrasts of light and dark values.

I always work with a limited colour palette, which helps me focus on the tonal properties within the subject matter and create a degree of harmony in the finished painting. For example, *Copse on a Hillside, Anglesey* (opposite) was painted principally in mid-tone values using harmonious greens, blues and greys to evoke a calm, gentle mood. The focus in this painting is concentrated in the middle distance, on the interesting pattern of shapes.

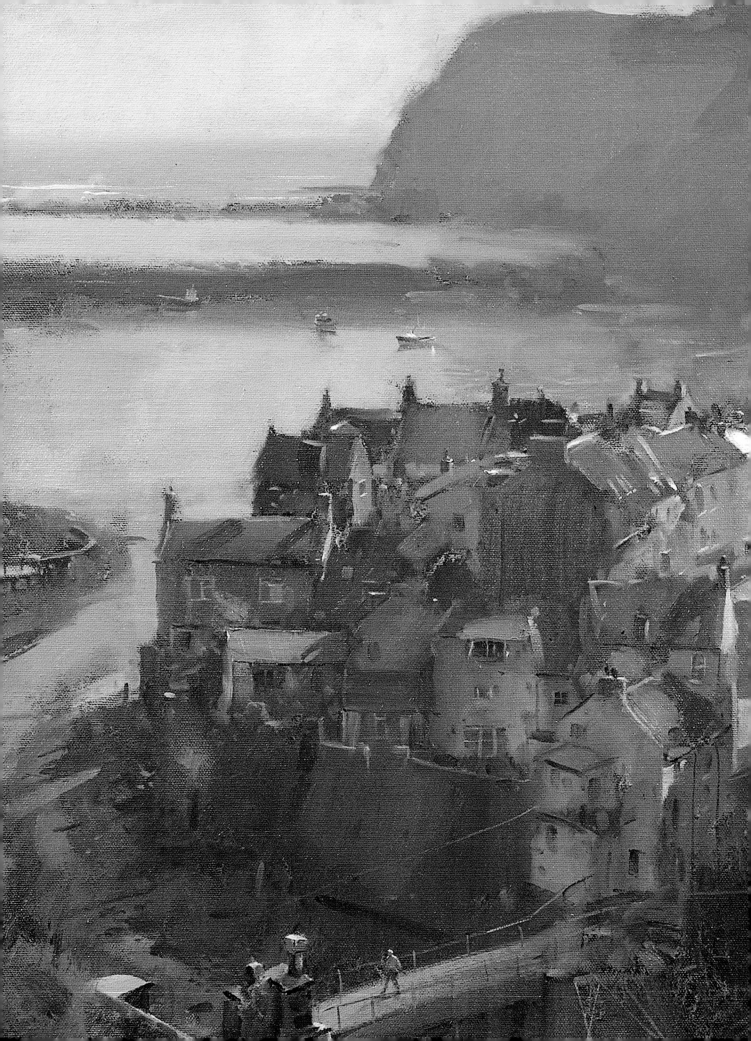

PICTURE PROFILE
First Light in September, Staithes Harbour

Light was the inspiration for this subject, which I painted on site between 7am and 9am on a fine, mid-September morning. I liked the mood of the scene, created by the quiet, slightly diffused early morning light, which I knew, at this time of year, would remain fairly constant for at least a couple of hours. Probably after that the dark tones in particular would become more intense and the shapes sharper and more defined.

The view was a familiar one – I often paint at Staithes in North Yorkshire – but as always I looked for something different in the composition. In this case it was partly the atmosphere of the scene, but also the fact that I wanted to try a square-format painting, which was something I had not tried before at Staithes. The square format is very appealing, I think, because it makes you concentrate on what you feel is important about the subject matter. It encourages a more disciplined approach to composition. From my vantage point, I could see that this particular view would give some useful directional lines in the composition, as well as an interesting sequence of block-like shapes and juxtapositions within the mass of buildings. In this case the low-key colours and tones were exactly the ones I wanted to capture in the painting, so I needed to work quickly.

I chose a 51 x 51cm (20 x 20in) gesso-primed canvas panel, working directly onto the white surface. I started with a general wash of colour and then lifted out the lightest areas, such as the foreground bridges and the distant sea area, with a rag. Thereafter, essentially the technique was *alla prima*, a 'one-hit', wet-on-wet approach, working with large brushes and vigorous strokes to capture as best I could the wonderful sense of light and the transient quality of the scene.

First Light in September, Staithes Harbour

OIL ON CANVAS BOARD

51 x 51cm (20 x 20in)

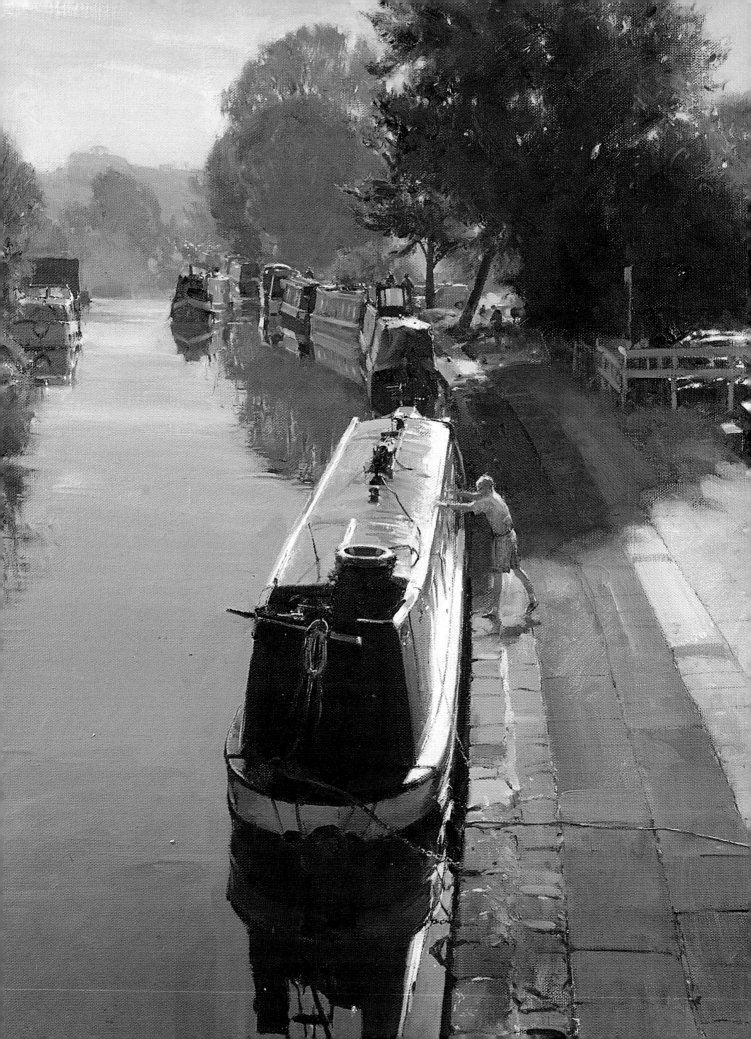

Initial Decisions

The most appropriate medium to use, and the best support and size to work on, are crucial choices that have to be made at the very start of a painting. Inevitably these decisions can have a profound influence on its ultimate success or failure. The choice of medium is often determined by the conditions of the day – the light, weather and so on, as well as one's mindset and the subject content. Time is also a factor, of course, and similarly this has to be assessed in relation to the location, subject matter and quality of light.

Fine October Morning,
Clayworth Wharf

OIL ON CANVAS

66 x 51cm (26 x 20in)

❝ For studio oil paintings I prefer to work on linen canvas with a pre-prepared primed surface. In the studio there is more time to develop and refine elements, although equally I want the painting to have energy and spontaneity. ❞

With subjects such as *Dining Room Interior, Blackwaterfoot Lodge, Isle of Arran* (below), for which there is a reliable, consistent quality of light, there are no constraints regarding time and therefore, if desired, the opportunity to work on a reasonably large scale. However, other subjects might be quite complex and much more dependent on sound drawing, as in architectural subjects, or perhaps influenced by changing conditions, such as light and tides. Here, the options are either to work on a small scale or to make a sketch or take some photographs as reference for a studio painting later on.

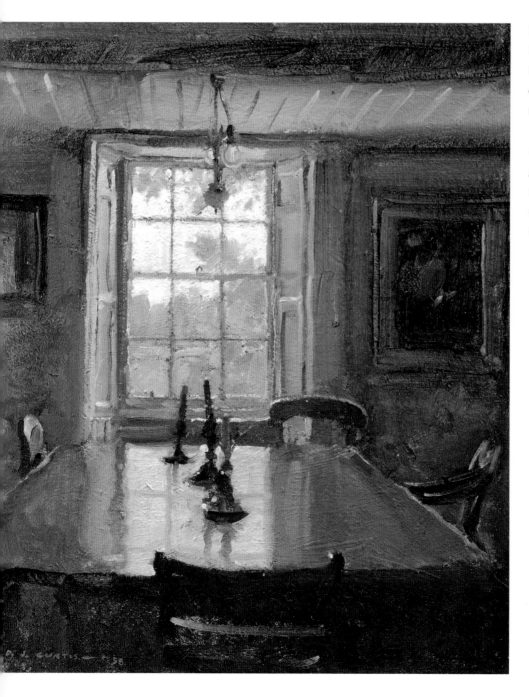

Dining Room Interior, Blackwaterfoot Lodge, Isle of Arran

OIL ON CANVAS

56 x 46cm (22 x 18in)

" *I decided to use a limited palette of low-key colours for this subject, to enhance the effect of the light coming from the window.* "

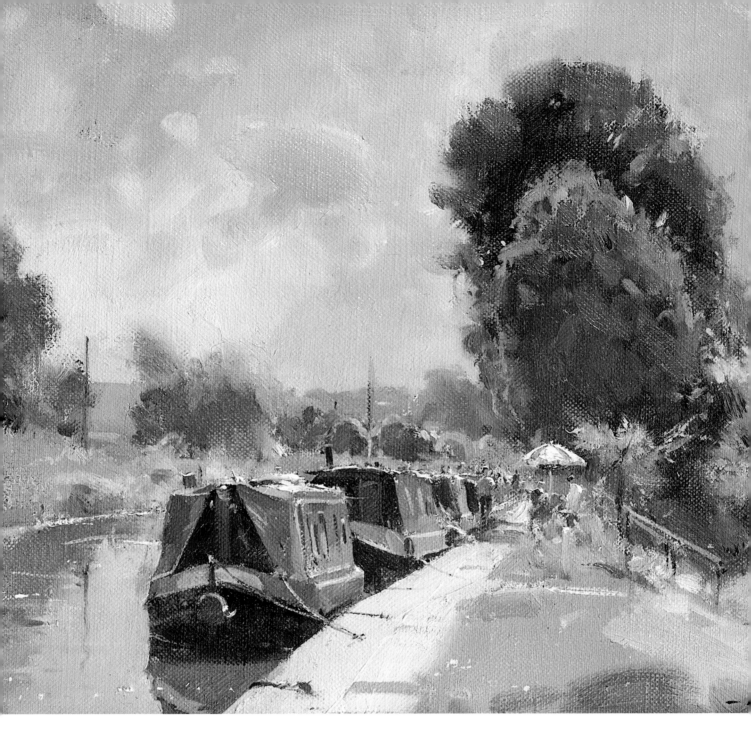

Bright July Morning on
the Chesterfield Canal

OIL ON CANVAS BOARD

25.5 x 30.5cm (10 x 12in)

*❝ In contrast to Dining Room
Interior, Blackwaterfoot Lodge,
Isle of Arran (opposite), with its
summery greens, this is a very
high-key colour subject. ❞*

Sometimes, having completed a studio painting in this way, from
location studies, I may then decide to paint another version of the subject,
using the original painting as the reference and this time working in a
different medium and on a larger scale. For example, I quite often work
from one of my *plein-air* oil studies and make a larger and more resolved
watercolour painting. The scale is always relevant to the subject matter and
situation. In the studio I often work on a full sheet of watercolour paper,
57 x 78.5cm (22¹/₂ x 31in) or on a 61 x 76cm (24 x 30in) canvas, or larger.
Outside, I usually paint on prepared gesso-coated boards or a Saunders
Waterford watercolour block, but I seldom use anything much larger
than 30.5 x 40.5cm (12 x 16in).

Subject and medium

For me, it is the nature of the subject matter – essentially whether it is
a very atmospheric scene or something that would be best captured with
more decisive brushstrokes and colour – that is the most influential factor in
determining the choice of medium. Usually when I am working on site I have
both oil painting and watercolour equipment with me, so there is no problem

The Dog Walk, Misson

OIL ON BOARD

35.5 x 25.5cm (14 x 10in)

❝ *I have always felt that there are tremendous advantages in being able to work in more than one medium, as this creates more opportunity to use the medium that will best suit the subject and conditions – which for my* plein-air *work is now often oils.* ❞

in making an appropriate choice. The only exception to this is for painting trips abroad. Due to the restrictions that currently apply to carrying oil painting mediums and similar materials on planes, I now often work in watercolour when I travel abroad. If I need an alternative for oil paint, I use alkyd colours, which in any case have the advantage that they are much faster drying.

Another important factor about painting abroad, of course, is that I am not usually seeking finished paintings that are fit for exhibiting. Rather, I want to create good reference material that I can work from when I return to my studio. However, when there is an opportunity to complete something on site, especially in the UK, I find it more rewarding and successful to work in oils, particularly if the subject is about light and if it can be expressed in blocky areas of colour. But, if the subject is soft-edged and ethereal in character, as in *Capileira, Las Alpujarras, Andulucia* (below), then there is nothing more fitting than watercolours.

Breadth of experience

I have always believed that the ability to reap the greatest rewards from painting is much enhanced if you can work in more than one medium. Many established artists paint in both watercolours and oils, or acrylics and oils, and invariably my advice to aspiring painters is to develop skills in at least two contrasting media. As well as enabling you to have a choice, and with it the potential to interpret subjects and ideas in a more fulfilling way, the

Capileira, Las Alpujarras, Andalucia

WATERCOLOUR ON PAPER FROM
A SAUNDERS WATERFORD
WATERCOLOUR BLOCK

24 x 35cm (9½ x 13¾in)

❝ *Full of atmosphere and subtle colours, here was a subject ideally suited to a soft-edge, wet-into-wet watercolour technique.* ❞

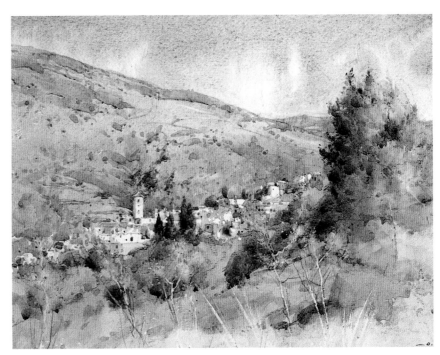

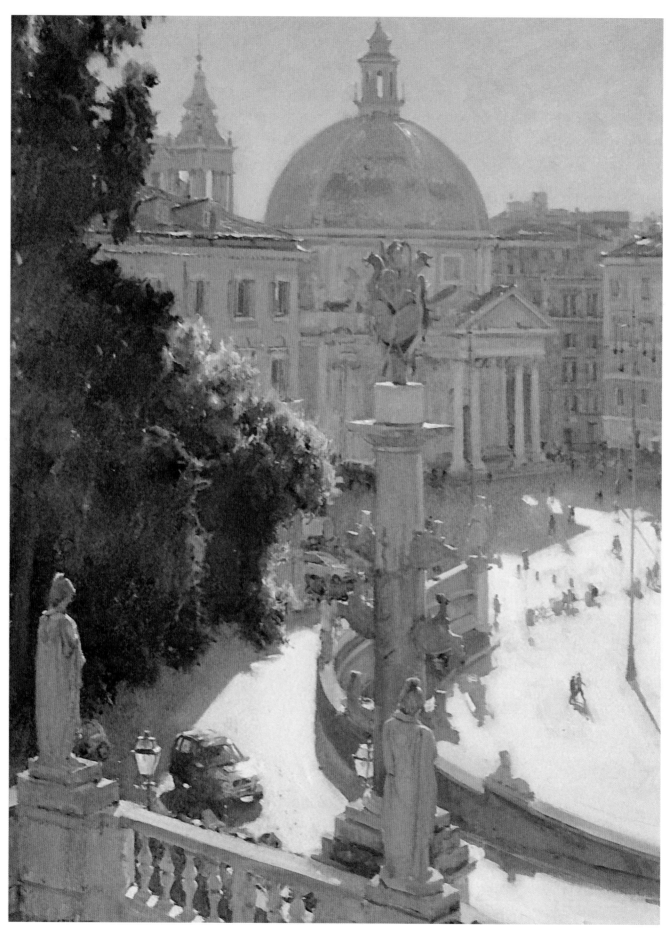

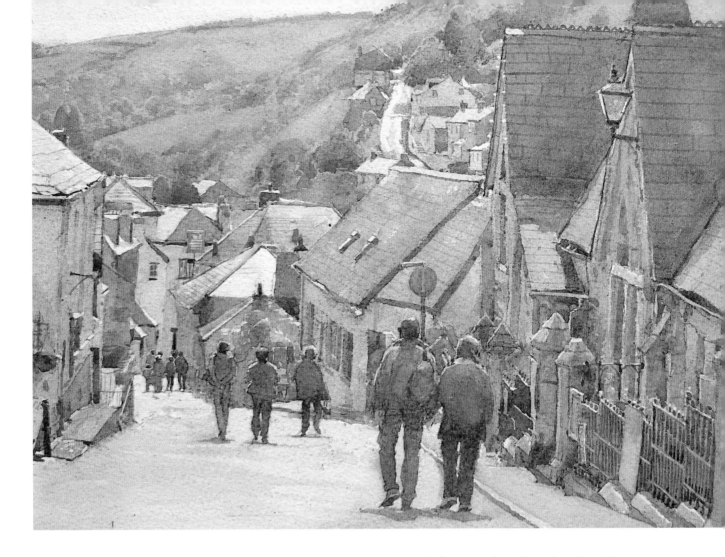

**Downhill to the Harbour,
Port Isaac, North Cornwall**

WATERCOLOUR ON ARCHES PAPER

28.5 x 38.5cm (11¼ x 15¼in)

*With reference to their scale
in different parts of a painting,
figures are always a useful
element in creating a sense
of depth or perspective.*

Piazza Del Popolo, Rome

OIL ON CANVAS BOARD

66 x 51cm (26 x 20in)

*In this studio painting
I made the most of the strong
contre-jour light effect and
bold shapes.*

challenge and experience gained from different media will profoundly add
to your knowledge of painting and your development as an artist. Moreover,
the struggle with one medium can help inform and encourage better work in
another. I know from my own work that the fluidity of watercolour creates an
interesting contrast to the plasticity of oils and, equally, a better understanding
of it – and vice versa.

I find it curious that the majority of painters start with watercolour,
which to my mind is a more difficult medium to master than most others.
As a young teenager, my first attempts in painting were in oils and, as I
discovered, this is a more forgiving medium because it is slow-drying and
consequently allows you to scrape off paint and make adjustments. In
watercolour it is very difficult to change your mind about something
and carry out radical alterations.

Later, I tried pastels and spent over a year exploring this sensitive
medium for drawing and painting landscapes. My experience of different
media was further enhanced by a summer spent using line and wash
techniques, working with a Flomaster pen and watercolour washes. This
eventually encouraged me to try watercolour painting in its own right. Since
then, from my early twenties, I have always had the option of the two media:
oils and watercolour.

D. J. CURTIS.

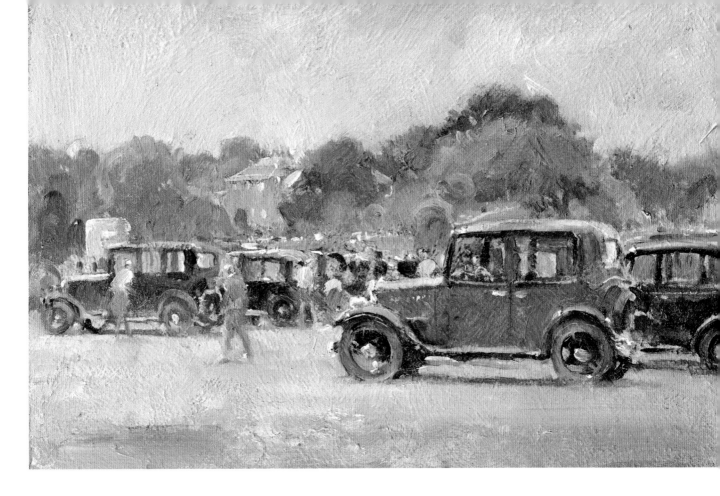

The Austin Rally, Derbyshire

OIL ON BOARD

18 x 25.5cm (7 x 10in)

❝ *I love painting outside and, as with this painting, I often work from a pochade box to make small oil studies.* ❞

A High Aspect, Manarola, Cinque Terre, Liguria

WATERCOLOUR ON ARCHES PAPER

78.5 x 57cm (31 x 22½in)

❝ *Before starting a studio painting, ensure that you have enough reference material – not just photographs, but also sketches made on site. For subjects in which there is a lot of drawing and detail, watercolour is usually the most fitting choice.* ❞

Appropriate choices

I like to paint outside whenever possible and now I often work in oils, essentially because I can work much quicker that way and still capture the subject with, I hope, a fair degree of impact and originality. *The Austin Rally, Derbyshire* (above) is typical of my *plein-air* approach in oils. The subject matter, with its mainly hard-edge shapes and the fact that there was a lot of activity going on, required a speedy response, as nothing would stay in place for very long. For this reason I chose to work in oils on a small, prepared board. I knew that, by working on a small scale and using oils, I could quickly develop the composition, building with blocks of colour and concentrating on shapes and tones.

Time was not such a factor for *Dining Room Interior, Blackwaterfoot Lodge, Isle of Arran* (page 50). However, in this case I chose oil paint because, to capture the heavily contrasting lights and darks, the painting needed bold, resonant colour. I began with a strong underpainting and then, with a rag, rubbed out the lightest areas – so immediately creating an indication of the dramatic light effect that I wanted. I doubt if I could achieve that weight of tone in watercolour. In contrast, the perspective, complexity and amount of drawing and detail that were likely to be involved in *A High Aspect, Manarola, Cinque Terre, Liguria* (opposite) meant that watercolour would be the best choice for this subject. This was a studio painting, developed from sketches and photographs.

Freedom and control

Whatever the painting medium you choose, there is something really enjoyable and exciting about applying colour to paper or canvas. But naturally the means and reliability of working with paint can vary considerably from one medium to another. Each medium offers a different experience, with its own particular strengths and challenges. I love the 'feel' of oil paint, its textural possibilities and the way it can be worked and shaped with a brush. For me, as I have explained, oil paint is a more sure-fire medium. Nevertheless, I also find immense pleasure and satisfaction from working with watercolour, despite its somewhat unpredictable nature. Indeed in many respects it is a more challenging medium, for quite often the result is as much influenced by good fortune and happy accidents as it is by one's skill and experience.

Bubion Village Street, Alpujarras Mountains
WATERCOLOUR ON PAPER FROM A SAUNDERS WATERFORD WATERCOLOUR BLOCK
26.5 x 35.5cm (10½ x 14in)

"For a watercolour subject such as this, do not be afraid to make use of the white surface of the paper for the highlights and white areas. If necessary, important highlights can be temporarily protected with masking fluid."

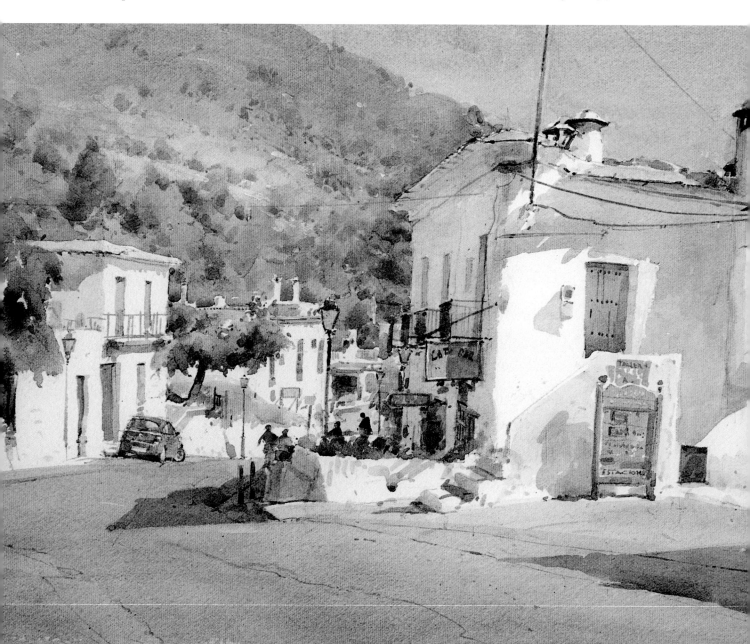

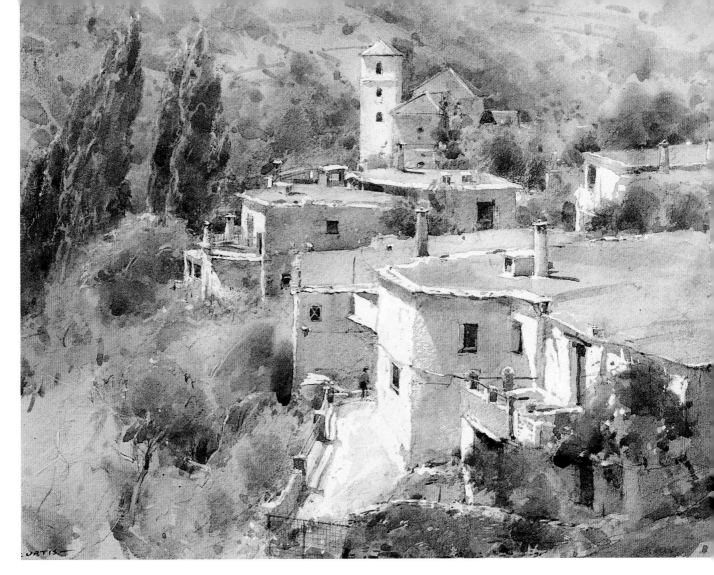

Restrained colour washes

Church and Rooftops,
Bubion, Sierra Nevada
WATERCOLOUR ON PAPER FROM
A SAUNDERS WATERFORD
WATERCOLOUR BLOCK
24 x 35cm (9½ x 13¾in)

❝ *As here, I often start a*
watercolour painting with a
general variegated wash, to
establish a foundation from
which to work. This particular
subject proved a challenging,
complex design for plein-air
work. ❞

Usually, the key to successful watercolour painting lies in the skilful application of appropriate colour washes – whether these take the form of flat washes (even colour), graduated washes (light to dark) or variegated washes (in which there are subtle colour changes). Equally, for most types of subject matter it is important to start with a sound drawing to establish the necessary shapes and proportions. In fact, with watercolour, this is the only stage of the working process in which you can confidently make alterations, as any faint pencil lines are easily erased with a putty rubber, without damaging the paper surface.

Another important point to bear in mind is that the character and impact of each colour wash will be influenced by the type of watercolour paper chosen and whether the surface is wet or dry. My main technique is the 'ghost' wash, an initial continuous weak, variegated wash that I use to establish a foundation from which to work. For me, this stage is always an intense 'make-or–break' one. My aim at this point is to set the course for all the formative elements of the painting – its mood, tonal contrasts, colour harmonies and so on. The intensity and difficulty can be all the greater

when working outside in a hot country, as I did for *Church and Rooftops, Bubion, Sierra Nevada* (page 59).

This delightful subject was painted on site, working on paper from a Saunders Waterford 24 x 35cm (9½ x 13¾in) block – my usual choice of paper for *plein-air* work, when time is a factor. Because of the nature of the subject matter, with its focus on the groups of buildings and their unusual perspective when viewed from above, a careful initial drawing was essential. The next step was to apply masking fluid to protect the light shapes of the buildings and then, as soon as this had dried, I dampened the paper and worked on the 'ghost' wash. Because of the high temperature at this location it was obviously important to work quickly, especially with the initial variegated wash, so I ensured that I had generous quantities of the relevant colours mixed and ready to use.

You can see that in parts of the foreground and in quite a lot of the background area, the 'ghost' wash has been left to create subtle general tones, which suggest rather than define – in contrast to other parts, such as the cypress trees, in which further colour washes were added to develop form and tone in a more resolved way. Once the first wash had dried I rubbed off the masking fluid. Then I put in the windows before, again with restrained

A Steam Rally, Nostell Priory
WATERCOLOUR ON CREAM-TINTED TWO
RIVERS WATERCOLOUR PAPER
28.5 x 38.5cm (11¼ x 15¼in)

❝ *I believe it is better to understate something rather than overplay it and this is particularly so in watercolour. Note in this painting how I have left some areas simply stated with the initial 'ghost' wash, confining the detail to the central area, which forms the focus of interest.* ❞

washes, working on the shapes of the buildings, essentially concentrating on the play of light and shadows. In the surrounding area I used the different greens of the foliage to cut into the buildings and help define their form. I chose a very limited colour palette, which I think helped both in creating the right mood and harmony for the painting as well as in a practical sense, given the time constraints. Here, as in all my paintings, success in developing form, meaning and interest relied principally on using tone against tone, keeping the detail to a minimum.

Similar considerations applied to the other two small *plein-air* studies, *Cottages by the Cliff* (below) and *Capileira, Las Alpujarras, Andalucia* (page 53). The charm of such paintings, I feel, lies in their simplicity. You have to honour what is in front of you, yet focus on essentials. Such paintings are 'of the moment' and often have a greater intensity and spontaneity than those made in the studio. Usually, the most important issue to address is the effect of light. The crucial choice you have to make is whether to accept the light effect as it is when you start the painting, or wait, if you anticipate that it will improve. Of course, once the main lights and darks are established in the painting, there is no going back – those tonal contrasts will determine a particular mood and impact.

Cottages by the Cliff

WATERCOLOUR ON GREY-TINTED

TWO RIVERS WATERCOLOUR PAPER

16.5 x 23cm (6½ x 9in)

66 *Just as I use tinted boards for* plein-air *oil studies, with watercolour I sometimes choose a tinted paper if I think it will enhance the mood and character of the scene.* 99

Stage 1

PENCIL SKETCH

❝ *In the pencil sketch I concentrated on the principal shapes and the rhythm of the composition.* ❞

Stage 2

❝ *For the initial 'ghost' wash I used a mix of Indian yellow, raw sienna and permanent rose to indicate the main tonal and colour values.* ❞

A moment in time

One aspect of *plein-air* painting that I always relish is the sense of urgency that is required to capture the essence of a scene before a change in the light or other conditions radically alters those qualities that were the initial inspiration. My painting of *Nether Cantley Lane* (page 64) demonstrates the working process that I normally adopt for outdoor subjects and the importance that I attach to such elements as composition and colour harmony in helping to capture a sense of place and a certain moment in time.

Old Cantley in South Yorkshire is an attractive village and is one of those places that I can regularly return to and find fresh inspiration. But I had never before tried a portrait-format composition, which for this particular view was ideal as it enabled me to emphasize the impressive scale and character of the autumnal trees. I chose a viewpoint that included a useful 'lead-in' device on the left – the ivy-clad wall – and set the lane off-centre. My aim was to convey the feeling of late autumn in this quiet country area.

I started with a pencil drawing on the watercolour block, to show the shape of the cottage and the basic tree forms (Stage 1, above). As you can see,

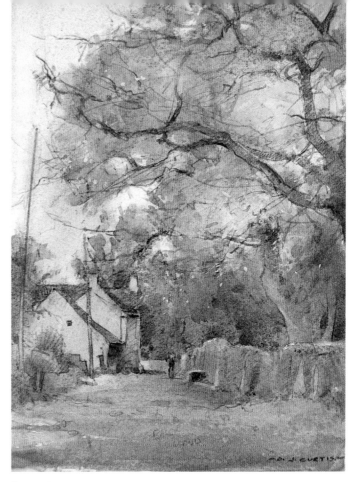

Stage 3

66 *Here, I considered the darkest tones on the cottages and beneath the trees and checked that the cottages gave the right sense of distance.* 99

Stage 4

66 *Now I could work on the trees and build up their tonal values and structure in relation to the rest of the painting.* 99

this is quite a resolved drawing, although small-scale. When producing a drawing like this, I try to anticipate how it might help the later stages of the watercolour painting. Here, for example, there are lines and tones that will eventually help with the structure of the cottage roof, with a similar approach used for the trunks and branches of the trees. While maintaining an underlying sense of draughtsmanship and vigour in the composition, many of these lines will be absorbed into the colour washes later on.

For the initial 'ghost' wash (Stage 2, opposite), I included Indian yellow, raw sienna and a touch of permanent rose, running these colours together and aiming to suggest a feeling for the backlit effect, contrasting with the deep shadows beneath. I always view this first wash as a very important stepping stone towards how the painting will be developed later on. For this reason I find it much better to apply a continuous variegated wash rather than separate flat washes.

Then, I make decisions about the strongest darks and create a guide for the tonal range that I am going to use. I also begin to firm up some of the shapes (Stage 3, above). In this painting, the darkest area was at the side of the cottages, under the eaves of the first gable end. There were also some

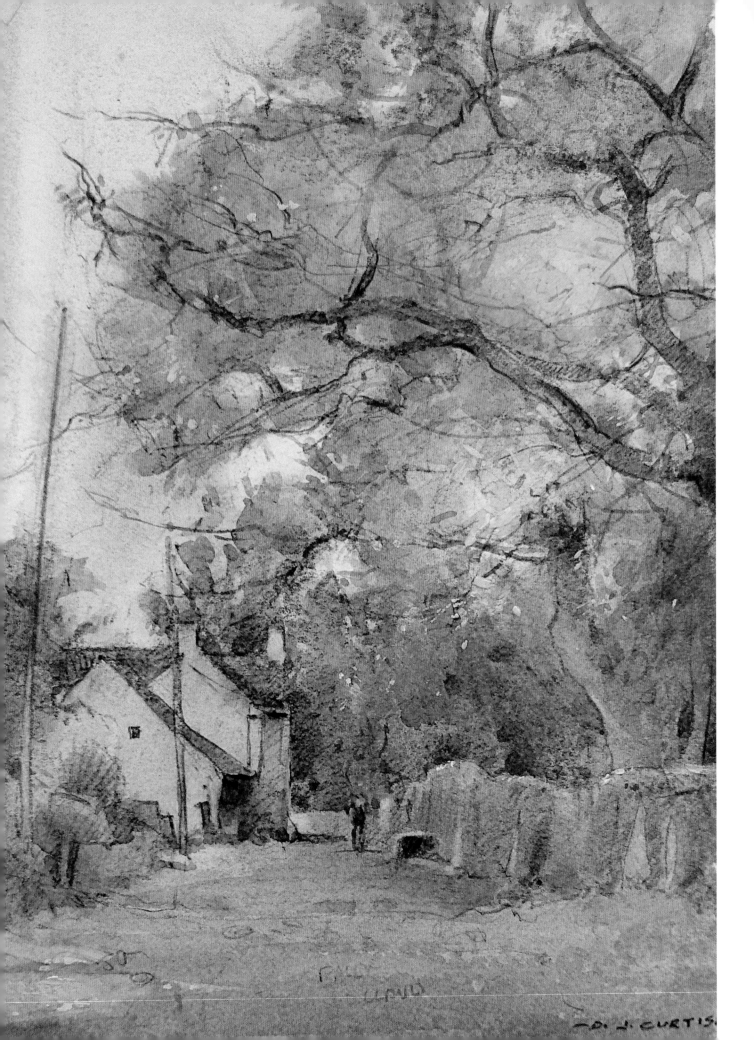

D. J. CURTIS

Nether Cantley Lane

WATERCOLOUR ON PAPER FROM

A SAUNDERS WATERFORD

WATERCOLOUR BLOCK

20.5 x 15cm (8 x 6in)

“ Finally, I checked to see whether any aspect needed enhancing, to add to the impact of the painting. I looked particularly at the success of the design, lost and found edges, and colour and tonal contrasts. ”

fairly strong tones beneath the trees. I placed these tones and worked on the buildings, to ensure they were set in the right sense of distance. In this way, gradually the painting starts to reveal itself – it is rather like an old Polaroid film developing.

Each part of the painting must be considered in relation to the rest, so next (Stage 4, page 63), to counter the structure and tonal values of the buildings, I made some decisions about the branches of the trees and how strongly to pitch these against the light effect beyond. I wanted them to have some very dark elements, yet look three-dimensional and add to the sense of form and space, rather than create silhouettes. Also at this stage, I strengthened the tonal contrasts on the wall at the right, to increase the feeling of recession in the painting.

The final stage is to make a careful assessment of the whole painting, enhancing tones and highlights as necessary and ensuring that everything works to the greatest advantage and impact. In the final painting, *Nether Cantley Lane* (opposite), I did more work to emphasize the tonal contrasts and I also added more interest to the foreground area, enhancing the link between the glancing light and colour of the dead leaves in the lower left-hand area of the painting, and those of the trees above. As always, my aim was to do just enough, but not to go too far and so overstate the effect.

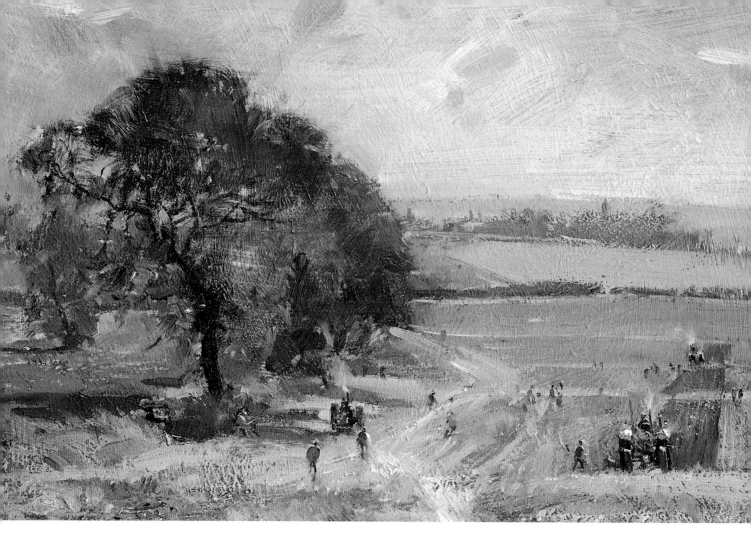

The all-weather medium

Although watercolour is a wonderful medium for location work, especially for capturing mood and atmospheric qualities, its scope is often limited in wintry and damp conditions, when the colours become more difficult to handle and there can be problems with the lack of drying. However, with oils these issues seldom apply, since the plasticity of the medium will allow you to tease out the most incredible effects, even when conditions are harsh.

For me, oil paint is the prime all-weather medium: whatever the weather there is always the chance of at least blocking in the essence of a scene – I have on occasions painted in a snowstorm. I accept that sometimes it can be difficult to carry back wet paintings without damaging them, but I never use really thick paint, especially for quick *plein-air* studies, and if there are a few smudges, these are easily corrected when I am back in the studio.

Painting *alla prima*

Outside, it is essential to work quickly and directly, applying the oil paint more or less as finished colour, and so with little or no subsequent modification. This technique is known as *alla prima* ('at first'). The intention

**Festival of the Plough,
Epworth, Doncaster**

OIL ON BOARD

20.5 x 30.5cm (8 x 12in)

This small, pochade box study was painted on a dry, sunny September day, aiming to evoke the atmosphere of a ploughing match in full swing.

is to create a response to the subject matter and produce a finished, or virtually finished, painting in a single session of work, which is usually about two hours. This type of work is intense, vigorous and spontaneous – I think it is often more successful in capturing the moment and sense of place than the larger, more resolved paintings that are produced in the studio.

As for *Rocky Headland near Porthcothan, North Cornwall* (below), I normally work on prepared gesso-primed hardboard panels for these small *alla-prima* paintings. I take a selection of boards with me – different sizes and prepared with different textures and grounds – so that I can choose the most appropriate surface for the subject I have in mind. Some boards are left white, while others are painted with a neutral-colour turpsy wash. This could be a cool tone, perhaps using a mix of French ultramarine and raw sienna, or a warm tone, with French ultramarine, raw sienna and burnt sienna. The white boards are for those subjects in which there are strong highlights and thus suit my 'rub-out' technique. For this I apply the initial general wash on site and, while it is still wet, I use a rag to lift out those areas where I want the extreme lights.

Rocky Headland near Porthcothan, North Cornwall is the ultimate *plein-air* subject, demanding the most acute observation and the need to work quickly – I spent about $1^{1}/_{2}$ hours on this painting. To capture the effect of surging

Rocky Headland near Porthcothan, North Cornwall

OIL ON BOARD

25.5 x 30.5cm (10 x 12in)

For this wonderful coastal scene, with the sea breaking onto the rocks, I worked with very direct, loose brushstrokes.

waves crashing onto rocks requires a lot of discipline. You have try to
understand the rhythm of the waves, the ebb and flow, note what happens,
remember it and place it. At a glance, it seems a fairly simple subject, mostly
sea and rocks. However, there are many subtleties in the forms and colours,
and many challenges in trying to convey a sense of movement in the waves.

I painted this subject on a board prepared with a medium texture and
a cerulean blue ground. I always use the smooth side of the board, which is
prepared first with a coat of acrylic primer, and then with a coat of gesso
primer and texture paste mixed together, usually in equal proportions. For
trips to Cornwall, I know I will need a lot of these cerulean-wash boards –
they suit the wonderful colour of the Cornish sea. Obviously for this type of
painting the technique is mainly wet-into-wet, although also using paint with
more body for the final highlights. In *Rocky Headland near Porthcothan, North
Cornwall*, essentially the highlights are the white water of the breaking waves.
To suggest these with some conviction, I worked with a feathery upward
stroke of the brush.

From the Balcony, Manarola

OIL ON CANVAS BOARD

20.5 x 25.5cm (8 x 10in)

 *I liked the interesting
'V'-shaped composition that
this scene made, as well as
the contrast between the
jumble of rooftops on the
left and the deep shadow
of the hillside opposite.*

The Plantation Area, Stanage Edge, Peak District

OIL ON BOARD

30.5 x 40.5cm (12 x 16in)

Working plein-air, *on a cold, bright March morning, I chose a view that I hoped would convey the drama of this impressive gritstone escarpment.*

Expressive marks

In the studio, as there are no constraints on time or likely problems with changeable lighting or other conditions, the work can be more ambitious, both in terms of scale and content. However, because there is time to reconsider every brushstroke, there is always a risk that studio paintings can become laboured and lose their sense of vitality and interest. My aim with such paintings is to achieve the same impact and qualities that I aspire to when working outside, namely to create a convincing sense of mood and place, and to express this in a way that is interesting and original.

For studio work I usually paint on linen canvas, choosing a medium-textured surface for most landscapes, or perhaps a rough weave for more expressive ideas. I prefer the primed surface to be fairly thick, so when I buy canvases I normally treat them with a further coat of acrylic primer, over the ones that are already there. Sometimes I use an oil-based primer, if I want a slightly less dry surface.

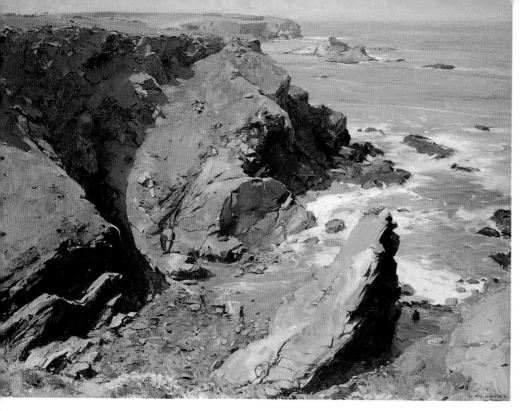

I might work from sketches and photographs, or use one of my finished oil or watercolour *plein-air* paintings as the reference. For example, for *Sea Cliffs at Porthcothan, North Cornwall* (above), I worked from a smaller oil painting that I had made on site, perched precariously on a cliff top, and I also had some photographs. I thought the subject was so fascinating and had so much potential that it deserved a bigger scale, in which I could develop the surface textures and subtle tonal changes in a more satisfactory way.

As you can see, there is a glorious arced shadow that enlivens the whole composition, with which I was helped by the photographic reference. In the studio I follow a similar painting process to that which I use on site, but of course it is less urgent and so there is time to develop and refine elements. But once again, the essentials are good composition, sound drawing and convincing tonal and colour relationships.

Colour palette

Colour contributes to the impact of every painting. It is mainly the choice of certain colours, their placing and relationships that creates the distinctive mood in a painting. Equally, colour plays a vital role in creating an effective design and in influencing the viewer's response to a work. Some subjects are essentially high key in colour – in other words, involve bright, warm colours and light tones – while other scenes are more subdued in their colours and are said to be low key. I most enjoy the challenge of capturing the subtleties of colour and I will subdue colours rather than enhance them but I think this is necessary when, as for me, a vital objective in every painting is the interpretation of light and mood.

Choosing a colour palette

Colour is an emotive quality and naturally the way that artists observe and respond to colour is a very personal, subjective thing. Some artists are said to have a 'warm eye' and consequently are likely to give full emphasis to the colours inherent in the subject matter. Other artists have a 'cool eye' and tend to focus on tonal qualities rather than expressive colour. I would describe myself as a tonalist rather than a colourist.

Our approach to colour determines the colour palette we use: it has to suit our character and the way that we want to interpret ideas. It takes time to develop the most appropriate colour palette, as essentially the only method to achieve the best workable set of colours is by trial and error. It took me many years to settle on the colours that I use today and interestingly there are some subtle differences in the colours that I use for oils and those for watercolours. The colour palette must include the primary colours so, having started with a selection of those, you can gradually adjust and build up a range of colours that will work best for you.

My advice is to keep the colour range fairly limited. A limited palette is easier to work with and it helps ensure that the paintings have a sense of harmony. The use of lots of colours can look overbearing and be counter-productive as far as achieving impact is concerned. As I have already inferred, the colours that are perfect for one medium may not necessarily prove ideal for another. For instance, although my principal colours for oils

Old Forge Interior, on the Sandbeck Estate, South Yorkshire

OIL ON CANVAS

51 x 61cm (20 x 24in)

This subject was an unexpected find and, in its complexity of content, light, shade and perspective, required me to draw on all my past experience.

**The Beach,
Monterosso al Mare**

OIL ON BOARD

20.5 x 30.5cm (8 x 12in)

"Especially when painting plein-air, my advice is to keep to a limited palette – it is easier and quicker to work with, and will ensure a sense of harmony in your work."

and watercolours are quite similar, I have never found that cobalt blue works successfully for me in oils, although in watercolour it is an absolute essential, especially in the initial washes. Instead, in oils, I like a mix of French ultramarine and cerulean, rather than cobalt. This gives me an excellent blue to use with other colours for creating greens, greys and purples, which are colours that suit my tonal approach.

Obviously the subject matter influences the choice of colours, but I will also adapt the palette to suit whether I am painting in the studio or outside. There are also some differences between painting in the UK and painting abroad. For oils my full range of colours in the studio is: titanium white, cadmium orange, cadmium red, permanent magenta, cobalt violet, viridian hue, terra verte, burnt sienna, raw sienna, cerulean blue, French ultramarine, transparent gold ochre, Indian yellow, Winsor lemon, buff titanium, Naples yellow and Naples yellow light. However, normally I only use about half of these colours and a more restricted range when I am painting outside.

For watercolours my palette includes: cobalt green, viridian, French ultramarine, cerulean, cobalt, cobalt violet, raw sienna, permanent rose, cadmium orange, burnt sienna, gamboge, Indian yellow, cadmium red and vermilion. This suits all subjects, both in the studio and on location, although I sometimes add other colours, such as yellow ochre and light red.

For my trips abroad, especially to the Mediterranean, I take a greater selection of yellows, while for Venice I would certainly include light red, because of the terracotta buildings. I never use Chinese white or white gouache in watercolour. If I need to enrich the highlights, I use a tiny amount of titanium white acrylic colour.

Working with a limited palette

It is always worth experimenting with new colours and, if necessary, replacing a colour or adding to those that you normally use. I would not wish to give the impression that once you have found a colour palette that works you should not try anything else. Nevertheless, I think that when it comes to painting specific subjects, it is always best to keep to a limited palette. Look for the colours that are pertinent to the subject matter and the impact that you want to achieve and don't be tempted to introduce other colours simply because they look exciting on the palette.

My preference is for subjects that are observed and painted *contre-jour* ('into the light'), so that the emphasis is on tonal effects rather than strong colour. However, occasionally I am also attracted by subjects that are in full light, as with *The Slipway, Sennen Cove, Cornwall* (opposite). There were some lovely shapes and colours in this subject, which I painted on site, working from a fuller range of colours than usual. I particularly liked the bold interaction of the two complementary colours – the bright cerulean blue of the sky and the cadmium orange sails of the boats. The painting contrasts areas of calm with areas of strong interest. In developing the composition and use of colour, my aim was to focus attention on the most exciting elements within the subject matter.

PICTURE PROFILE
Gunnera by the Pond

Decisions start with the choice of subject matter and sometimes, as I found with this particular subject, you don't have to look far to discover something really exciting and challenging to paint. These gunnera plants are in my garden. I painted them *in situ*, on a beautiful September day. I looked in the garden and these plants, caught in the sunlight and with their top-lit highlights and amazing slaty-blue shadows, were instantly inspirational.

For speed and impact of interpretation, I chose to work in oils, selecting a 30.5 x 40.5cm (12 x 16in) panel, prepared with a grey-blue ground. I started with the dazzling light on the pond, quickly blocking that in with a series of impasto brushstrokes, working with a mix of titanium white and lemon yellow. At the same time, I used the white paint to cut in around the lower leaf shape on the left, thus beginning to define it. I used a similar technique for the extreme darks in other areas. So, by placing the 'negative' shapes, I could start to suggest the structure of the surrounding leaves.

With the tonal range established, I moved on to place the yellow light on the upper leaves, to ensure that I captured this before the light changed. Then, for comparison, I added the autumnal ochre colour of the maple leaves in the top left-hand corner. The lighter green leaves were blocked in with a mix of lemon yellow and raw sienna, plus a touch of viridian, while the darker greens included French ultramarine. With the carefully considered colour, contrasting tones and strong, complementary shapes, the structure of the painting was now coming together. All that remained was to add the more linear brushstrokes, such as the grasses, and enhance some of the colour contrasts on the leaves.

There are decisions with every brushstroke in a painting. Certainly when you are working outside, from direct observation, the process is quite intense. As discussed in this section of the book, the most important decisions always relate to the subject matter, choice of medium, the appropriate scale and surface to work on, and fundamental elements such as design and use of colour. Given the time constraints and other factors, I do not think I could have produced such a satisfying painting of *Gunnera by the Pond* in watercolours, although now, with the experience of the subject and a finished painting as reference, I would feel confident about making a watercolour version in the studio.

Gunnera by the Pond

OIL ON BOARD

30.5 x 40.5cm (12 x 16in)

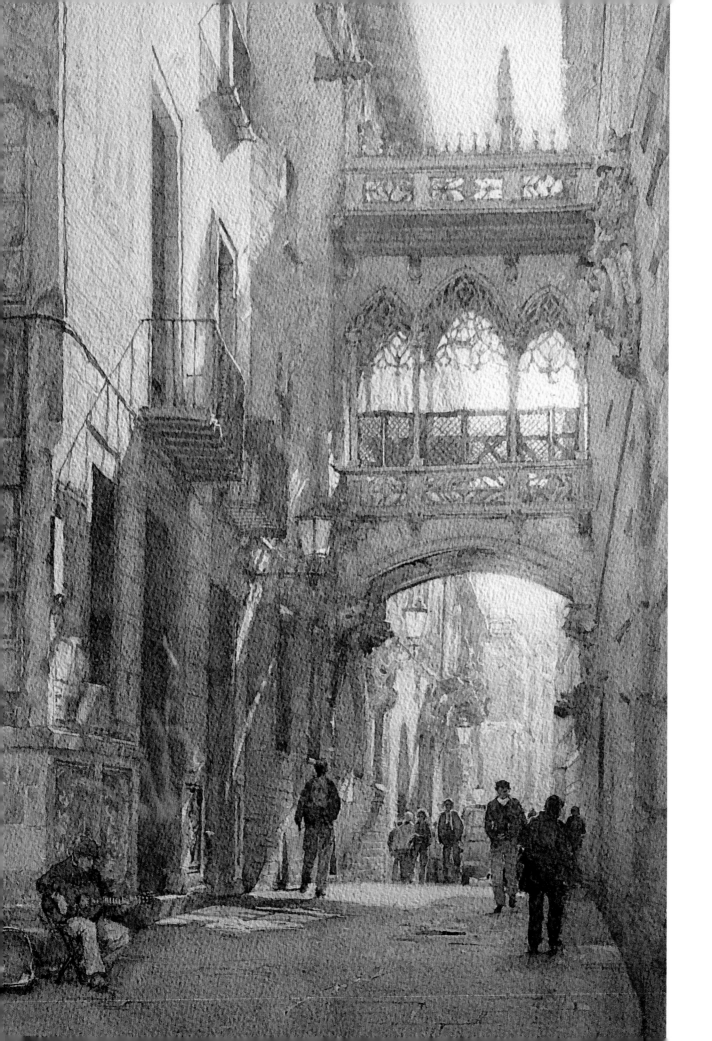

Interpretation

I firmly believe that paintings should always show a personal response, both with regard to the chosen subject or idea and the means by which this is expressed. Naturally, when we first start painting there can be a strong desire to copy exactly what is observed in the subject matter – in effect, simply to record what is there. While there is value in this, particularly in helping to develop skills in observation, drawing and in interpreting colour, such work often lacks real impact. It may well show sound technique and ability, but where is its soul, its individuality and emotional response? These qualities come from the perception, sensitivity and interpretative skills of the artist.

Street Musician, Barcelona

WATERCOLOUR ON ARCHES ROUGH

57 x 39cm (22½ x 15¼in)

Even with a wonderful subject such as this, to paint creatively and with feeling, the process must involve a certain amount of selection, exaggeration and imagination.

It is the particular elements within the subject matter that strike us as important and to which, consequently, we want to draw the viewer's attention, that make a painting individual and interesting. Inevitably, to paint creatively and with feeling, the process must involve selection, perhaps exaggeration, and imagination. You must be prepared to allow the subject to evolve beyond the reality of what is seen.

Selection

Selection starts, of course, with the choice of subject matter. The success of a painting will always depend to a large extent on choosing something that is interesting and challenging to paint and therefore contains features that can be exploited in terms of design and technique. As I have mentioned, I am always looking for subjects that are unusual in some way, perhaps by virtue of the viewpoint, the play of light or the juxtaposition of shapes. Although a priority is the composition – the key shapes and structure inherent in the subject matter – I know that subjects are seldom ideal as found and that I will have to do a certain amount of manoeuvring and re-shaping with the content.

Brave Old Oak, Sandbeck

OIL ON BOARD

25.5 x 36cm (10 x 14in)

" Here, the tree makes a very bold statement, while the distant rooftops create a useful complementary colour among all the greenery. "

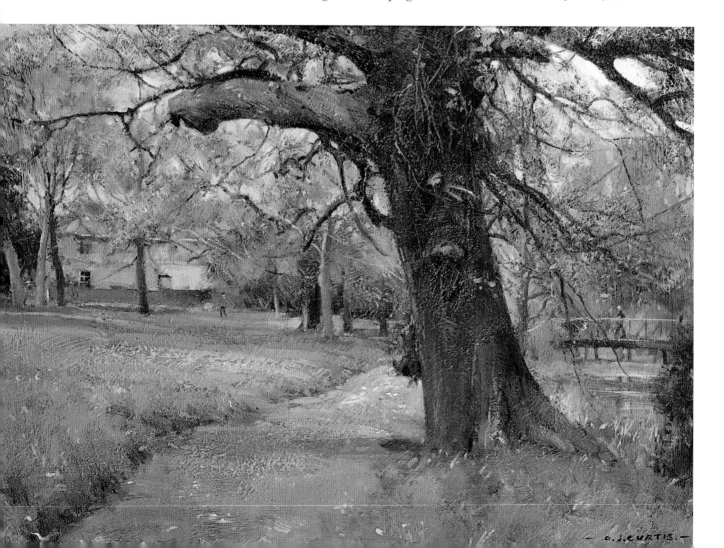

View to St Mary's, Whitby

WATERCOLOUR ON ARCHES ROUGH

38.5 x 28.5cm (15¼ x 11¼in)

❝ With its exciting contrast of sunlit and shadow areas, this was a wonderful subject to paint. ❞

The drama and impact of a painting is often enhanced by including some areas that are quiet and relatively uneventful, in contrast to others that enhance the general theme of the work. A large area of foreground might seem difficult to deal with, although in fact it can make a very useful lead-in element of the painting, particularly if it includes interesting directional shadows. Look at *View to St Mary's, Whitby* (above), for example, in which the dark, broadly treated foreground shapes create a striking contrast to the sunlit area beyond and at the same time 'frame' the view.

Interpretation **81**

Similarly, in *Heat of the Afternoon, Staithes* (above), note that the foreground is quite a simple, restful area, yet the sweep of the river leads the eye back to the middle-ground features of interest. When painting *plein-air*, timing is all-important: you have to assess when the lighting and other conditions will be at their best to add the greatest impact to the subject.

Points of interest

While it need not be particularly dominant in a painting, the focal point, or centre of interest, will play a vital role towards the success of the work in terms of its visual impact and the overall strength and integrity of the design. The accepted practice is that each painting is designed so that the visual 'journey' – the way that we are encouraged to follow a certain path around the work – leads us to a specific place. However, the design need not always be as straightforward as that: it can involve supporting points of interest, which often adds more substance and appeal, or enhances the mood of the painting.

Morning Coffee, Barcelona

OIL ON CANVAS

66 x 51cm (26 x 20in)

" *While this subject had a lot of good qualities, initially it lacked a real focus, so I decided to introduce the figure with the bicycle.* "

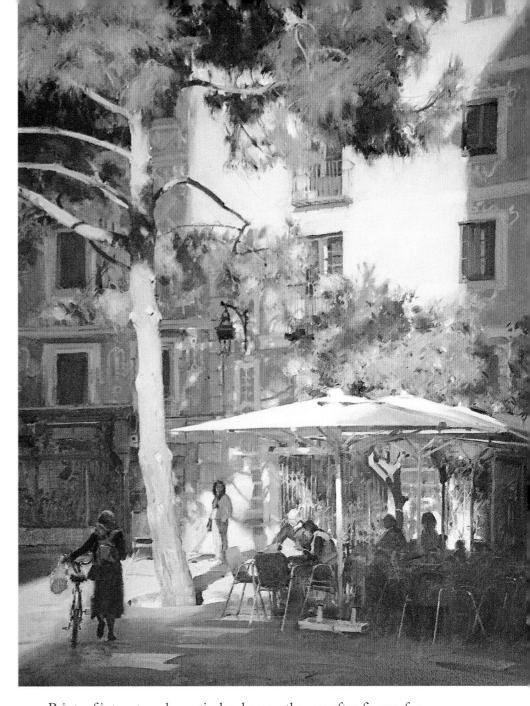

Points of interest can be particular shapes – they are often figures, for example – or they can be areas that create a focus within the painting, such as a strong highlight or a contrasting colour or texture. In *Old Bridge, Hayton, Chesterfield Canal* (opposite), for example, there is a lovely area of light under the bridge, which creates the main focal point and leads us up to the figure on the bridge, which is a second point of interest. Without the figure, the painting would be much less interesting. Again, in *Morning Coffee, Barcelona* (above), I have introduced a figure in a very deliberate way to provide a focal point. With its striking verticals, horizontals and the wonderful contrasts of light and shadow, this was an irresistible subject. However, it lacked a focus, which is why I added the figure with the bicycle in the lower left-hand section of the painting. Subjects are seldom perfect as they are and this is where the artist's judgement and experience come into play.

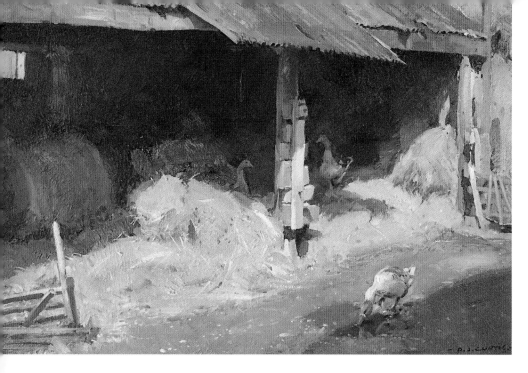

Haybarn and Geese

OIL ON BOARD

30.5 x 41cm (12 x 16in)

" So often it is the effect of light that gives a subject appeal and adds the necessary impact, as in this subject. "

Perception and interpretation

Very often, when you are painting, the choice of subject matter is actually the easiest decision to make. If something excites or inspires you and there is a real desire to paint it, what choice is there? Also, especially when painting on location, other factors can aid or limit your choice – the weather, for example. Whatever the subject matter and however you have arrived at the decision to paint it, the first important step is to assess its potential, the degree of challenge, and the best means of interpreting the different features and qualities that initially attracted you to the idea.

The obviously impressive subject, the grand design, isn't necessarily the best option, particularly if it means that you will be working in fear of not achieving everything you hope for. This is not to say that you shouldn't be

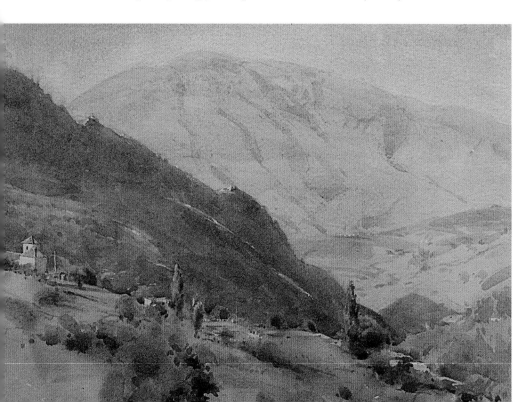

**Morning Light,
Las Alpujarras Mountains**

WATERCOLOUR ON PAPER FROM
A SAUNDERS WATERFORD
WATERCOLOUR BLOCK

28.5 x 38.5cm (11¼ x 15¼in)

" Drama in composition and drama in light – a perfect subject! "

Woodland Clearing

WATERCOLOUR ON BOCKINGFORD

39 x 57cm (15¼ x 22½in)

❝ *Here, there was no doubt that a watercolour technique would prove the best way to capture the early morning, spring light effect.* ❞

ambitious, but that equally the more personal, less pretentious scene can have a lot to offer. In fact, I generally prefer the smaller, more intimate subject. There is often much more scope for expressing one's own perception of what is seen. The magic of light is always appealing to me – a certain play of light can turn the most ordinary subject into a real gem to paint, as in *Haybarn and Geese* (opposite). This was a delightful little *plein-air* subject, but without the drama of light, it would not have caught my eye. You can't always trust your instinct: sometimes you just need to try a subject and see if it works.

Mood

For me, mood is usually synonymous with light. In most cases, the essential quality that attracts me to a subject is a particular effect of light. It is light that energizes a subject, adds the 'buzz' factor and gives it a distinctive mood and atmosphere. The milky, early morning, spring light effect in *Woodland Clearing* (above), for example, creates a very powerful sense of mood. Similarly evocative of place and atmosphere is *Morning Light, Las Alpujarras Mountains* (opposite), with its dramatic contrasts of light and shade. When painting such scenes on site, speed is always a factor, so the content and technique need to be kept within manageable limits.

Light and place

When painting on site, much of the inspiration, challenge and joy comes from trying to convey different light effects in a convincing way. I particularly like to work when there is a half-light effect, with the sun just breaking through the clouds. However, light is a transient quality: what is fascinating is how a change of light can transform an ordinary scene into one of great incident and interest. Because of this quality, in order to capture a scene with the optimum effect of light, it is essential to work quickly and confidently.

Subjects that I especially enjoy are those in which there are small, contrasting nuances of light, as in *Low Tide, Kettleness, from Goldsborough* (below). Trying to capture those little touches of golden light, such as those in the lower left-hand corner of this painting, is the most fascinating challenge. Also in this subject, I loved the glancing light across the sandstone cliffs and the soft, subtlety of the blues and the shadowy areas − plus the fact that the composition, from my high viewpoint, was stunning.

Similarly, in *Sunlit Bay, Staithes* (opposite) it was both the drama of light and the dynamic composition that I found inspirational. Here, you can see that the composition is comprised of the most wonderful sequence of triangular and 'V' shapes, which lead the eye into and around the picture area. Interestingly, this was a subject that I had not noticed at first: it could only be seen when standing at the very edge of the cliff, making it an extremely dangerous place to work from!

Low Tide, Kettleness, from Goldsborough
OIL ON BOARD
22.5 x 30.5in (9 x 12in)

❝ *The challenge of capturing small nuances of light, as with the touches of golden sunlight in this subject, is something that I especially enjoy.* ❞

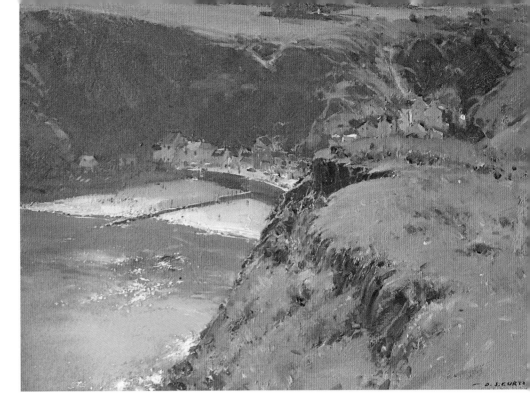

Sunlit Bay, Staithes

OIL ON BOARD

22.5 x 30.5in (9 x 12in)

" I love to find views like this, which offer bold shapes from which to develop an interesting composition for the painting – in this case using a sequence of roughly triangular shapes. "

Mood and technique

In capturing a sense of atmosphere and place, the choice of medium and approach is all-important, as are basic skills in handling formal elements (especially the tonal key and colour harmony) and aspects such as creating a believable feeling of space and recession. Because in seeking to evoke a certain mood for the painting it is necessary to understand and successfully convey the effects of light, essentially it is the sensitive and appropriate interpretation of light/dark values and tonal contrasts that is the most important factor in achieving convincing results.

Late Evening Light on the Beck

OIL ON BOARD

25.5 x 30.5cm (10 x 12in)

" Here again it is the effect of light that creates mood and, when outside, this is something I can achieve more quickly in oils than in watercolour. "

Piazza del Campo, Siena

WATERCOLOUR ON ARCHES ROUGH

39 x 57cm (15¼ x 22½in)

Where there are weaknesses in expressing mood, it is often the shadow areas, particularly the colours used for these, that are at fault. In mixing the colours for dark areas and shadows you must work from the parent colour (the actual colour of the object to which the shadow belongs). Shadows are seldom one colour all over, so look carefully and try to include some of the subtle variations of colour that you notice. Moreover, the colour of a shadow will also be influenced by the different surface textures and tones beneath it. Shadows can be more exciting than you think and my advice would be to avoid using colours such as Payne's grey and Vandyke brown when you paint them.

Obviously, when painting in the studio, without direct reference to the subject and divorced from the emotional response to it, creating an image that evokes feeling and mood is much more difficult. For these paintings, everything relies on your ability to recall how it felt when you were there, at the location, together with the quality of your reference material. Photographs can be useful, but are seldom a sufficient source of information on their own, unless you are painting a subject that you are very familiar with.

Piazza del Campo, Siena (above) was a wonderful subject for a studio watercolour and I hope I have managed to convey something of the activity and atmosphere that I experienced when I was there. In fact, my reference was

With a studio painting it can be much more difficult to evoke feeling and mood. Good reference information is essential, plus the ability to recall the experience of being at the scene. For this painting my reference was an oil study that I made on site.

an oil study that I had produced on site. Particularly with architectural subjects such as this, it is vital that the reference material is sound and sufficient enough. If the proportions are inaccurate, for example, or the light effect is inadequately observed, then what chance is there of successfully capturing the sense of mood and place?

Colour

The response to colour and the importance that is attached to it when painting are obviously factors that vary from one artist to another. For me, colour is seldom the main concern, although if it is an inherently significant feature of the subject and consequently a quality that will add impact to the painting, then I will exploit it. For example, colour is the key element in *Late Autumn, Clayworth* (page 91), where I have worked within a range of complementary blues, golds and yellows. Similarly, it is the stunning colour of the autumn foliage in *Maple in Autumn, Gibdyke House* (below) that adds the 'buzz' factor to this painting. In contrast, colour can also be a more subtle force, as in *London Skyline* (page 91), which is usually the approach I prefer.

Maple in Autumn, Gibdyke House

OIL ON BOARD

25.5 x 30.5cm (10 x 12in)

" A corner of my own garden, this was another subject in which colour was the inspiration. "

Particularly in watercolour, characteristics such as transparency, staining power and tinting strength can vary considerably from one colour to another. There are many books and courses available on colour theory and practice, but I believe that the best way to learn is always by painting and trying things out for yourself.

Colour is often a very attractive feature in a subject and because of this it can divert attention away from other important considerations when painting. However striking it might be, the colour must work in relation to everything else, and especially the composition. For example, in *Evening Sun over San Gimignano, Tuscany* (page 92), the inspiration was the beautiful sunlit colour on those iconic towers in the background. However, I was careful not to overplay the impact of that colour, as this would have destroyed the sense of distance. Again, in *Stream to the Beach, Sandsend* (below), the red accents do just enough to create the necessary contrast and interest.

Here, oil paint, with its resonance of colour, proved the perfect medium for expressing the varied textures and tonal qualities in the subject.

Stream to the Beach, Sandsend
OIL ON CANVAS
61 x 76cm (24 x 30in)

❝ As here, often just a few touches of contrasting colour are all that is needed to boost the impact of a subject. ❞

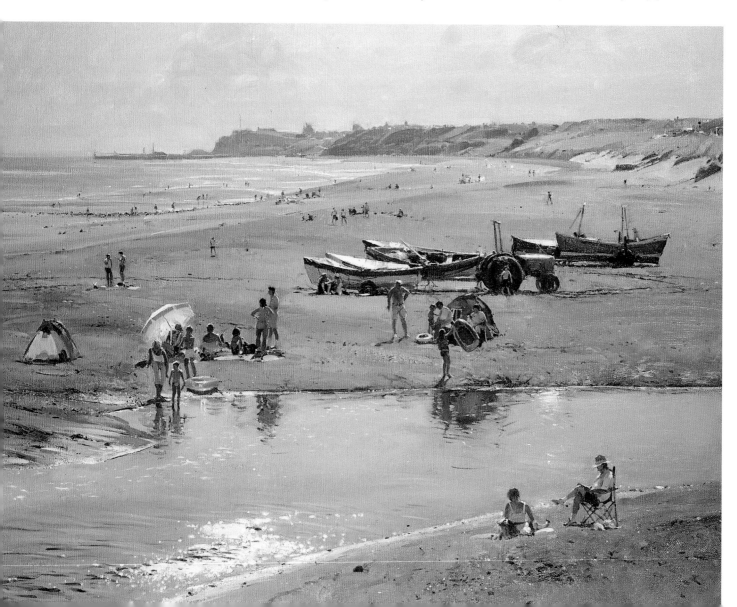

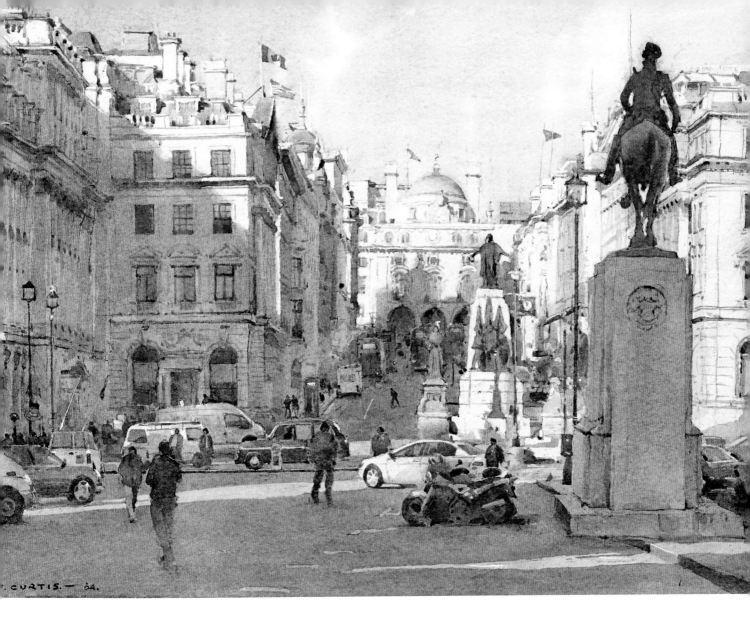

London Skyline

WATERCOLOUR ON ARCHES ROUGH

28.5 x 38.5cm (11¼ x 15¼in)

❝ Colour can be restrained but effective, as in this study of Lower Regent Street shows. ❞

Late Autumn, Clayworth

OIL ON BOARD

25.5 x 30.5cm (10 x 12in)

❝ With its complementary blues, golds and yellows, this colourful autumnal scene was a delight to paint. ❞

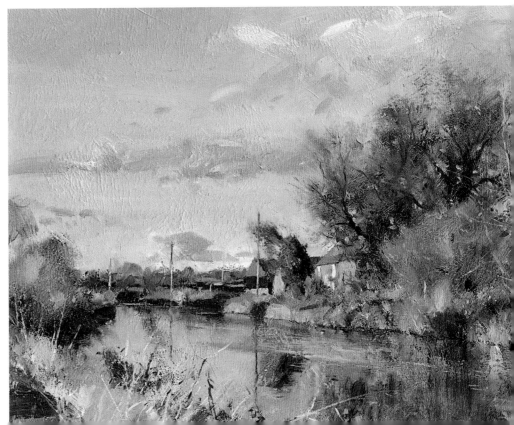

Colour properties

Because I am a figurative painter, essentially I work in a descriptive way, responding to the colours that I observe rather than adopting a more intuitive or expressive approach. However, as in other aspects of painting, it is important that the use of colour supports the chosen aims and impact for the work. Therefore, invariably it is necessary to subdue, limit, emphasize or otherwise modify the colours that are used. In considering colour, to gain the most from its interpretative and emotive qualities, it is vital to have an understanding of the particular characteristics and properties that define the different colours.

To create mood and impact in a painting, the relationship of warm and cool colours, tonal variations and counter-change (light shapes against dark and vice versa), colour harmony and colour contrasts (for example, juxtaposed complementary colours) can all play a part. Of course, it is necessary to gain experience in mixing colours in order to appreciate the subtleties of colour and tone that can be achieved and the differences between the various media.

Evening Sun over San Gimignano, Tuscany

OIL ON CANVAS

51 x 66cm (20 x 26in)

" Colour must always work in relation to other elements in the painting. In this scene, the particular challenge was not to let the warm colour of the buildings destroy the sense of distance. "

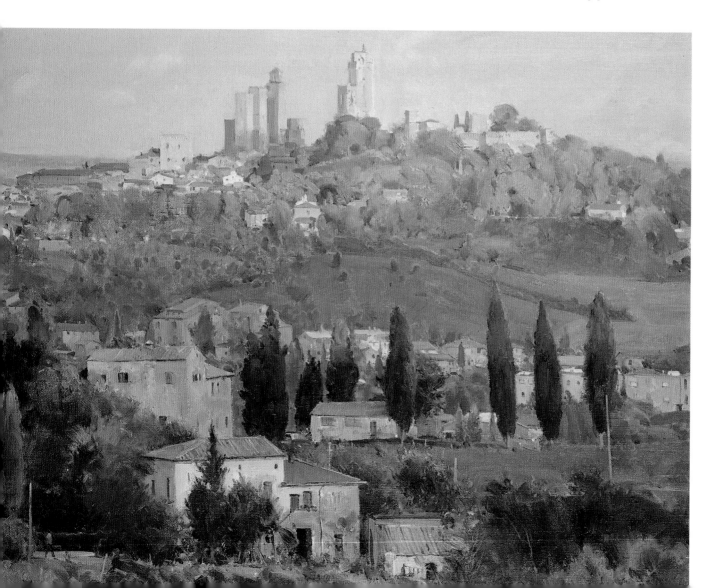

Impact

A successful painting must have impact, by which I mean that it should work in such a way that attracts and holds the viewer's attention, while offering something original and interesting to look at and think about. Impact need not necessarily involve high drama in the use of colour, content or other elements. Certainly it is not dependent on detailed representation or any particular style of working. In fact, the impact of a painting can be achieved by quite subtle means – by the harmony of colour or the mystery within atmospheric colour washes, for example, or the visual appeal of a clever composition. Indeed, this is how I like to create impact – it does not have to shout at you.

For me, it is often a certain quality of light that attracts me to a subject and that consequently I want to interpret to the greatest effect in the final painting, as in *Gathering Storm, Nanjizal Beach, Cornwall* (below).

Gathering Storm, Nanjizal Beach, Cornwall

OIL ON CANVAS

61 x 76cm (24 x 30in)

There are always wonderful effects of light and mood in beach scenes, which are one of my favourite subjects.

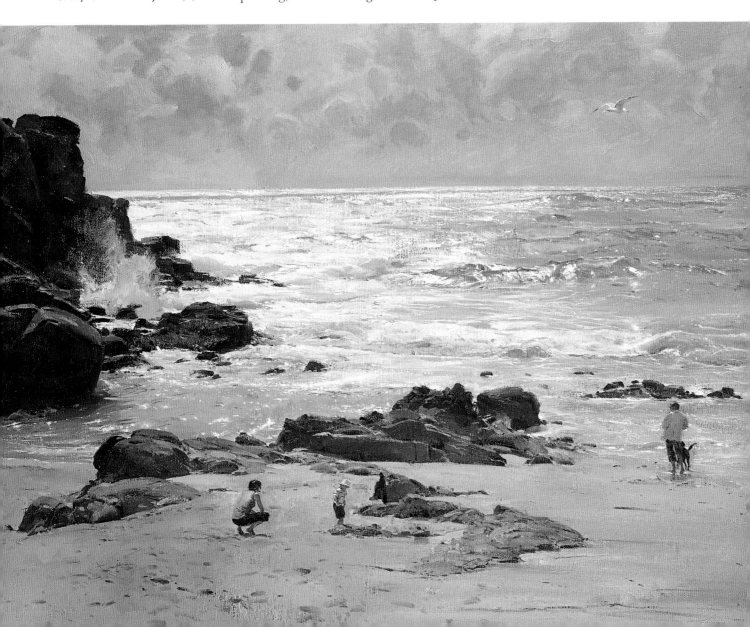

Subject and impact

The degree of impact depends on the skill of the individual artist in selecting, responding to and interpreting ideas. Judging the best viewpoint, and exactly which part of a complex scene to focus on, is always vital to the success of a painting and the sort of impression it makes. This was true for *Mevagissey Harbour* (opposite), for example. Had I taken a view more to the left or right, much of the energy and interest in the composition would have been lost.

The angle of the boats, the quality of light and the subtle colours combine to create the mood and impact of this subject. The viewpoint was also a key consideration in developing a strong, interesting composition for *Shadows and Reflections, Venice* (above). Another factor that can add to the impact of a subject such as this – a well-known subject that features in many artists' work – is to find something personal and different to the obvious sites.

Usually the drama and impact in my paintings comes from, I hope, the combined strength of the composition and the interpretation of light. To achieve this, the right choice of medium – oil or watercolour – is crucial. Watercolour was the instant choice for *Mevagissey Harbour* because of the subtlety of the different light effects. In contrast, the impact in *Garden Study with Veranda, Corfu* (opposite) depended on colour with more body and texture, for which oil paint was ideal.

Shadows and Reflections, Venice

WATERCOLOUR ON TWO RIVERS PAPER
28.5 x 38.5cm (11 x 15in)

❝ *In popular locations, I look for the less obvious subjects or unusual viewpoints.* ❞

Garden Study with Veranda, Corfu

OIL ON BOARD

30.5 x 25.5CM (12 x 10IN)

*❝ Both colour and the choice
of medium play decisive roles in
creating the impact in this painting.
By working with oil paint I was able to
develop bolder colour effects as well
as appropriate surface textures. ❞*

Mevagissey Harbour

WATERCOLOUR ON ARCHES ROUGH

51 x 71CM (20 x 28IN)

*❝ Often, it is a matter of isolating part
of a scene rather than attempting to
include everything. Had I moved more
to the left or right, this composition
would have been far less effective. ❞*

PICTURE PROFILE
On the Beach with Meg, Port Mulgrave

If the subject matter is inspirational, and you are eager to paint it, then there is a good chance that you will produce something with real insight and impact. I am always on the lookout for new, exciting subjects, which is exactly what I found at Port Mulgrave in North Yorkshire, on a visit there with my son and our dog Meg. In fact, I had painted at this location before, but I had never seen it with such a striking effect of light – it seemed to take on an entirely different character.

What I found particularly appealing about this subject was the wonderful interaction of blue and ochre shapes formed by the low sandbanks and the triangular pools of water left by the receding tide. Broken by the occasional rock and stretch of seaweed, this created plenty of visual interest across the huge foreground area. By exploiting the form of these shapes and the way that they meandered into the distance, I was able to develop a strong 'lead-in' effect for the painting. This, together with the subtle changes of colour and scale, imbues the work with a tremendous sense of space and atmosphere, I hope.

Working in the studio, without any time constraints, I was able to adopt a more considered approach in contrast to the one-hit, *alla-prima* technique that is necessary for *plein-air* paintings. For studio landscape paintings of this type, I prefer a medium-textured linen canvas, which I prepare with an additional coat of acrylic primer over the ones already there. The composition is based on reference material from location photographs and previous paintings of the subject.

Particularly with oil paintings, I never start with any detailed drawing. Instead, to encourage a loose and expressive response, I begin with just a few brushstrokes to indicate the basis of the composition. My son and the dog are carefully positioned to create a focal point (almost on the Golden Section) and they also add to the effect of counter-change – exploiting the contrast of light shapes against dark and dark against light – which runs throughout the painting. What I hope I have achieved is the feeling of a moment in time, a moment created by that special, transient flow of light that sweeps across the beach on a sunny but cloudy day.

**On the Beach with
Meg, Port Mulgrave**

OIL ON CANVAS

61 x 76cm (24 x 30in)

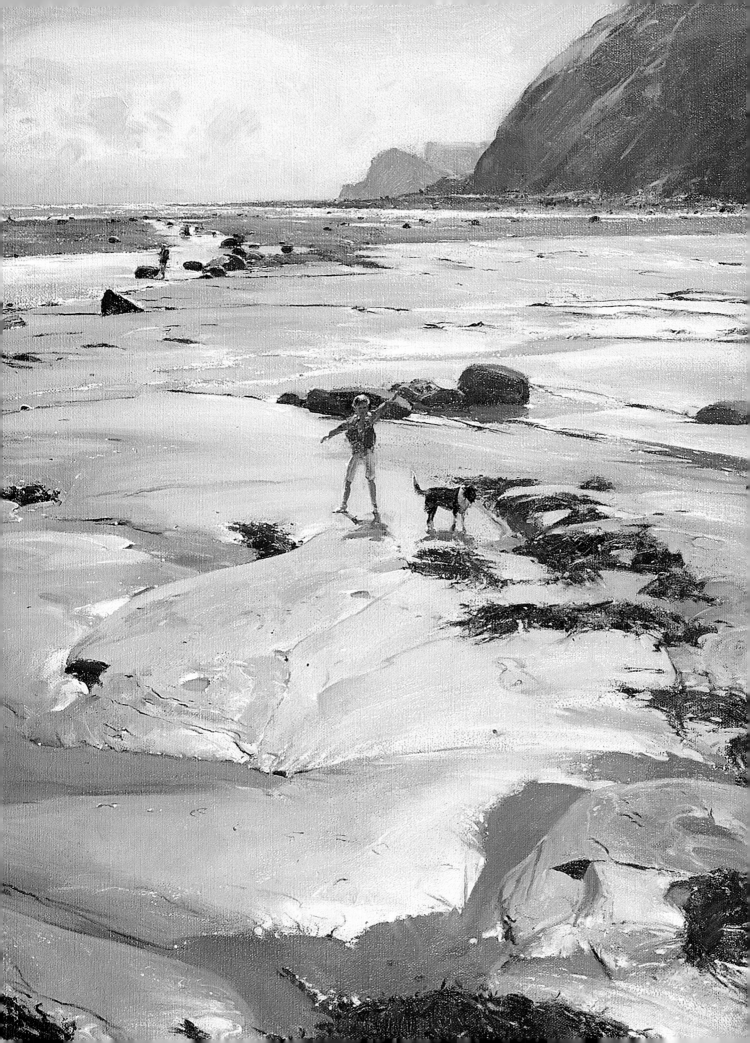

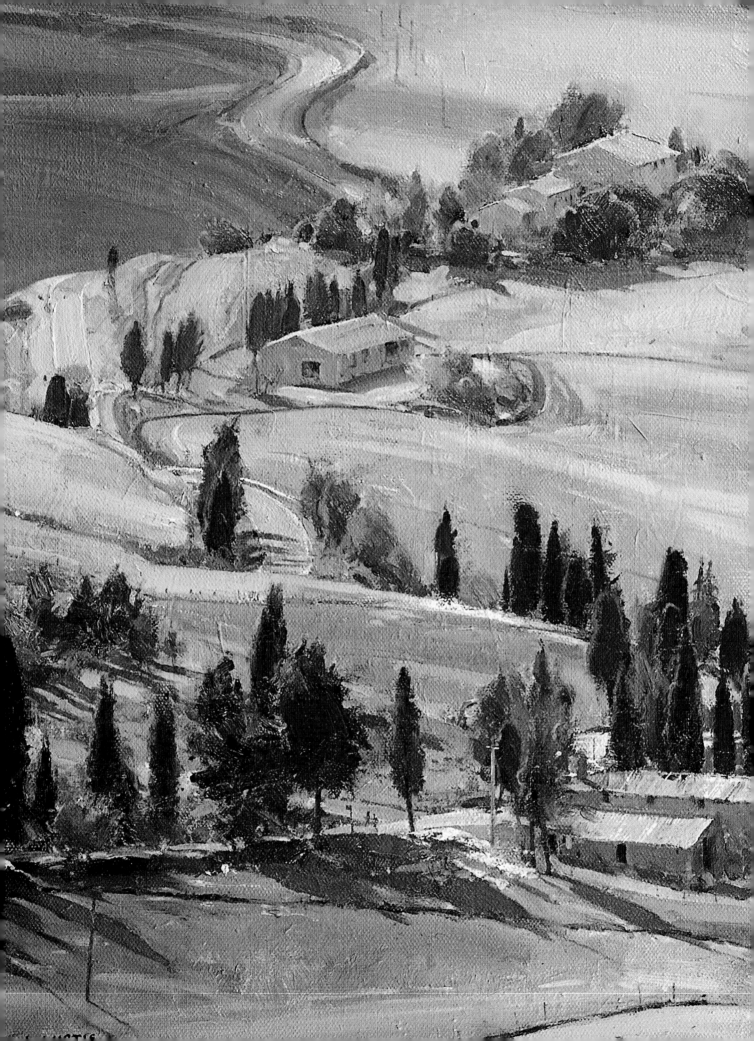

Themes and Variations

5

Some artists like to concentrate on a very limited range of subject matter, perhaps finding their inspiration from just one source, such as a particular landscape or an individual town or city. However, I prefer variety and apart from still life, which I have yet to consider, I enjoy the challenge and reward to be gained from painting many different subjects. Some of my favourites are beach scenes and interesting old boatyards and farmyards, but I also like painting various types of landscape throughout the seasons, boats and harbours, townscapes, interiors and people.

**View from a Terrace,
Volterra, Tuscany**
OIL ON CANVAS BOARD
40.5 x 40.5cm (16 x 16in)

" *Natural sweeping directional curves in the landscape often lend a most agreeable sense of design.* "

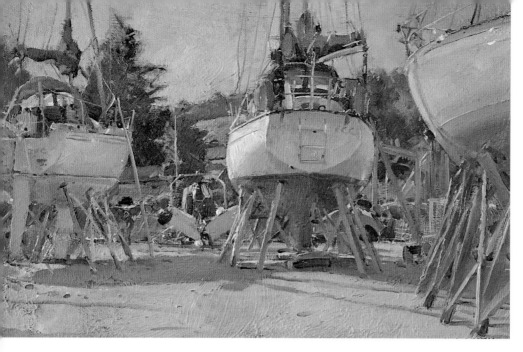

Ardfern Marina, Argyll

OIL ON BOARD

23 x 30.5cm (9 x 12in)

A complex subject, in which I have used the shape and direction of the outer boats to help focus attention into the centre.

Variety can help keep your work fresh and forward-looking, as well as test skills and add to your overall experience and ability. Naturally the choice of subject matter and the objectives for painting can change over the years, as you develop greater confidence and experience.

I now travel much more in search of new subjects, both in the UK and abroad. This is not to say that I have exhausted all my local subjects, of course, although I accept that it is now increasingly difficult to find ideas that have the strength of formal qualities – especially composition – and the degree of originality that I value. I think that one does develop a more discerning eye for those qualities. However, with a little more effort, I can still manage to find exciting subjects in familiar painting haunts such as Staithes and Whitby.

To maintain a desire for painting and keep the work lively and successful, it is necessary to raise the challenge level now and again. I do this by visiting new places, undertaking challenging commissions and setting myself ambitious projects. For example, at some time in the future I would like to try some more very large landscape compositions in which figures play a prominent part – rather like the set-piece paintings by artists of the Newlyn School and the Pre-Raphaelites.

Marine subjects

Harbours and estuaries are some of my favourite hunting grounds for exciting subjects to paint. There is every chance that I will find the sort of qualities that most appeal to me – dramatic effects of light with wonderful, interesting shapes and structures, offering the potential for strong composition and impact. Water and reflections, boat shapes, figures and a background of cottages and cliffs will all add to the atmosphere and challenge of the scene.

Marine subjects can be very complex – there might be 50 boats or more in a harbour – and therefore assessing what to include in your painting and

what to leave out is the first important consideration. Other key factors to take into account are the tide and the light. You need to choose the right moment, when the tide and the light give you the optimum impact, and quickly record that effect. If you are painting on site, concentrate on the water first, to indicate its essential character and level, and the position of the boats, before things change. I prefer subjects that I can paint while the tide is going out, so the water level is falling and any boats will be left stranded on the sand. This gives some wonderful light effects on the wet mud or sandbanks.

With such a variety of potentially exciting subjects, there can be a temptation to be greedy and include more in the composition than is necessary. Often, as shown in *Marina on the Argyll Coast* (below), a certain amount of restraint is required in order to achieve the most effective result. For this subject I decided to build the composition around the triangular sail, exploiting the repetition of the vertical masts and the angle of the three boat shapes and their reflections. The same considerations were true for *Ardfern Marina, Argyll* (opposite). By focusing in and selecting just the right relationship of shapes, I was able to create a more dynamic composition.

Marina on the Argyll Coast

OIL ON BOARD

23 x 30.5cm (9 x 12in)

❝ Marine subjects offer lots of interesting shapes and reflections to work with. I decided to use the triangular sail as the main feature in this painting. ❞

Dales and moorland

From my studio it is only a short trip into the Yorkshire Dales or the Peak District, where I can find open landscapes as well as more intimate rural scenes that are always inspirational. *An Old Courtyard, Worsborough Mill* (opposite), for instance, is typical of the quiet, almost forgotten type of farmyard subject that I love to paint. Although the barns in the background were fairly ordinary, for me, the scene was transformed by the inclusion of the old cart with its sun-bleached patina and, in consequence, in total harmony with its surroundings. It was the perfect subject for a small *plein-air* oil painting on board, using a limited palette and working with confident, expressive brushstrokes and blocks of colour.

This was a painting in which much depended on the success in handling a particular feature, in this case the cart, which required some sound drawing and the skilful application of perspective. Observation, a degree of simplification and experience all count in such situations. If you are not sure about painting something like this straight away, then start by making a separate drawing.

Climbers by the Great Slab, Millstone Edge

OIL ON CANVAS

61 x 51cm (24 x 20in)

66 *I often paint in the Peak District, which always impresses me with the majesty and timeless quality of its wonderful rock formations.* 99

An Old Courtyard, Worsborough Mill

OIL ON BOARD

30.5 x 40.5cm (12 x 16in)

" Rural scenes like this are now very hard to find, but they are one of my favourite subjects. "

For the more traditional landscape subjects, I quite often choose a scene in which there is a high horizon and the potential in the foreground to include an interesting feature that will entice the viewer into the painting. On a clear, winter day, driving across the North York Moors I found just the kind of subject I like and made the pochade-box study, *Sunlit Lane, West Barnby* (below). With its incredible composition, scintillating light effect and wonderful tree shapes, this was a really poetic and magical subject to paint.

In contrast, if conditions are favourable, sometimes I opt for a more ambitious approach and work on a larger scale, as I did for *Climbers by the Great Slab, Millstone Edge* (opposite), which was painted on a 61 x 51cm (24 x 20in) canvas. The Derbyshire Peak District is one of my favourite climbing areas and, as an artist, what particularly impresses me is the timeless quality of those great tors, which is something I try to capture and celebrate in my paintings. As a subject, the gritstone rocks are full of potential in terms of colour, tone and texture.

Sunlit Lane, West Barnby

OIL ON BOARD

20 x 30.5cm (8 x 12in)

" The combination of light and composition made this a magical subject to paint. "

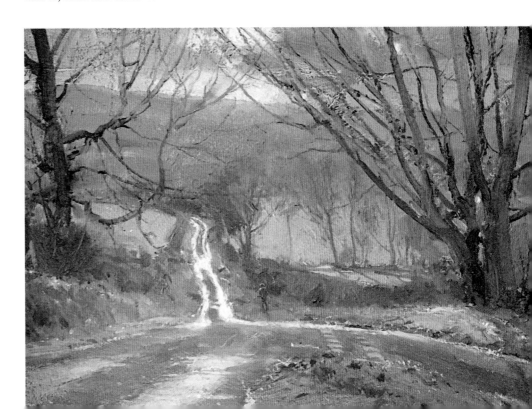

Winter Landscape, Everton

OIL ON BOARD

20.5 x 30.5cm (8 x 12in)

" I prefer trees in the winter when their form and structure is much more obvious and, in my view, more interesting to paint. "

The winter landscape

With its low light, long shadows and subtle blues, greys and purples, I love the winter landscape. True, it demands more resolve to paint outside in the winter, but however cold and whatever the weather, I venture out almost as much in the winter months as I do in summer, if for shorter periods. For these landscape paintings, as with all others, I look for subjects that offer a strong sense of form and structure, together with interesting qualities of light and colour.

In winter, the form of the landscape is much more evident, having lost the pervading green growth that masks everything and characterizes the summer woods and fields. I especially like the structure of winter trees, for example. If there are greens, I will usually underplay them, as I do in a summer landscape subject. The fact is that greens can so easily become overpowering and too vibrant in a painting, spoiling its credibility and impact. So my advice is always to mix greens rather than rely on colours such as Hooker's green or emerald green used in their raw state. If I start with olive green, for instance, I will probably add some raw sienna and a little lemon yellow.

Winter Landscape, Everton (above) is a good example of a subject that is full of interest and appeal in the winter, when the bare forms of the trees are showing, but has little to offer in the summer, when everything is lost under a canopy of green. Working in oils on a small, prepared board, my aim was to capture the essence of the fleeting light effect. I particularly liked the way this was enhanced by the reflected light in the pools of water in the foreground. Painted entirely on site, this little study took about 45 minutes.

For the much larger painting, *The Old Vicarage, Misson* (opposite), I was able to return on three consecutive fine days in February, working between

The Old Vicarage, Misson

OIL ON CANVAS BOARD

40.5 x 40.5cm (16 x 16in)

❝ *Sometimes it is possible to return to the same spot on two or three consecutive days and so attempt a larger and more resolved* plein-air *work, as here.* ❞

about 11am and 1.30pm, when the light was at its best for bringing out the contrasts in form and tone. For *Old Cottage Backs, Ledsham* (below), which is also a large painting, an early watercolour, I kept to a limited palette and broad washes of colour. Note how the foreground in this painting is very simple indeed, essentially a single wash of colour, but there is just sufficient tonal change to create interest and lead the eye into the painting.

Old Cottage Backs, Ledsham

WATERCOLOUR ON PAPER FROM
A SAUNDERS WATERFORD
WATERCOLOUR BLOCK

57 x 77.5cm (22½ x 30½in)

❝ *An early watercolour, worked with bold washes over an initial drawing.* ❞

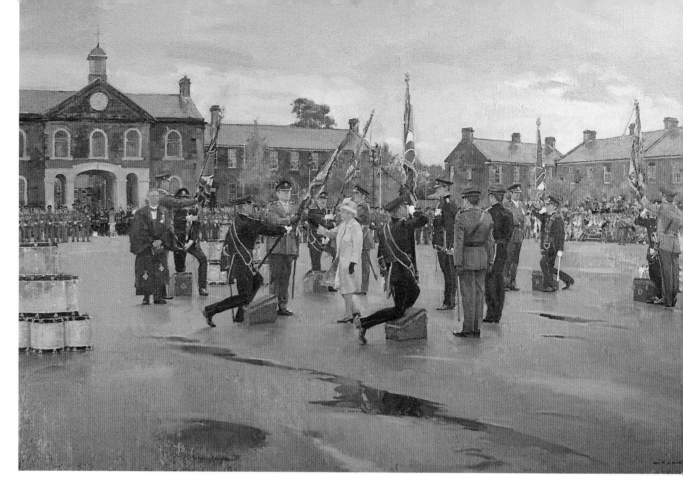

People and places

It requires confidence and skill to paint people and place them well in a
composition, particularly if they are going to be the main feature of the work.
The key to success lies, of course, in observation and sketching people – in
cafés, shops, stations and so on – and building up a useful resource of figure
studies in this way. Life-drawing classes are also extremely beneficial in
helping to understand how to capture pose, movement and character.

**Presentation of the Colours
by HM The Queen, The Duke
of Lancaster's Regiment 2008**

OIL ON CANVAS

96.5 x 132cm (38 x 52in)

❝ *This was a commissioned
work, which had to meet
certain criteria.* ❞

Letitia at the ROI 2007

OIL ON CANVAS BOARD

51 x 51cm (20 x 20in)

❝ *I like my portraits to have
similar qualities to my other
subjects, in that I want to create
a likeness but achieve this in a
loosely described way rather
than a highly detailed one.* ❞

Sally by the Fireside

WATERCOLOUR ON BOCKINGFORD PAPER

25.5 x 51cm (10 x 20in)

❝ *This is another early
watercolour study. Quick
studies like this are good for
building confidence with figure
work, as well as developing
painting techniques.* ❞

Sometimes it is the particular grouping or action of figures that is the
attraction of a subject and I will paint such a grouping on site, as at Henley
Regatta, for example, which I visited for a number of years. In other paintings
I often 'introduce' a figure or figures, if I think this will add to the overall
interest of the work and impact of the composition. Figures are an ideal
means of creating a focal point in a painting and giving a sense of scale.

As well as landscapes and other scenes in which figures are included,
equally I enjoy painting portraits and life studies. In a portrait, as in *Letitia at
the ROI 2007* (above), I aim for a likeness, but loosely described. On the other
hand, for a commissioned work such as *Presentation of the Colours by HM
The Queen, The Duke of Lancaster's Regiment 2008* (opposite), the content
is governed by an initial brief. This painting was a wonderful challenge: it
had to somehow honour the sense of event and ceremony, while including
12 to 15 identifiable people, with of course Queen Elizabeth II as the most
prominent figure. A large, studio painting, it took me over five weeks to
complete, working from the photographs, notes and drawings that I made
on location, plus the necessary research to ensure that every detail was correct.

Towns and cities

Towns and cities offer many different possibilities for paintings, from the compact, intimate subject to the more ambitious townscape with its sense of scale and atmosphere. Again, selection is a key factor in creating a successful painting and my advice is to look for a group of buildings that has an interesting skyline but that will equally give adequate foreground activity. As well as the various practical considerations when painting on site – and particularly in this case finding somewhere to work that won't attract too much attention from passers-by – you need to assess the degree of challenge and whether tackling it seems feasible in the time available. Alternatively, will the subject provide good reference material for subsequent studio work?

Lower Regent Street, London (opposite) and Barges on the Seine, Paris (below) show two contrasting approaches to painting city views. Lower Regent Street, London, which in fact was a demonstration painting that I made for a film, was produced in very difficult conditions in one of the busiest parts of London. Being essentially an architectural subject, it required some careful drawing, but, given the constraints of time and so on, I kept the colour work to mainly single, variegated washes. For the white buildings, I exploited the

Barges on the Seine, Paris
WATERCOLOUR ON ARCHES PAPER
57 x 77.5cm (22½ x 30½in)

66 Comparative scale and the overall balance and effectiveness of the composition are points to keep in mind when working from reference material for a view such as this. 99

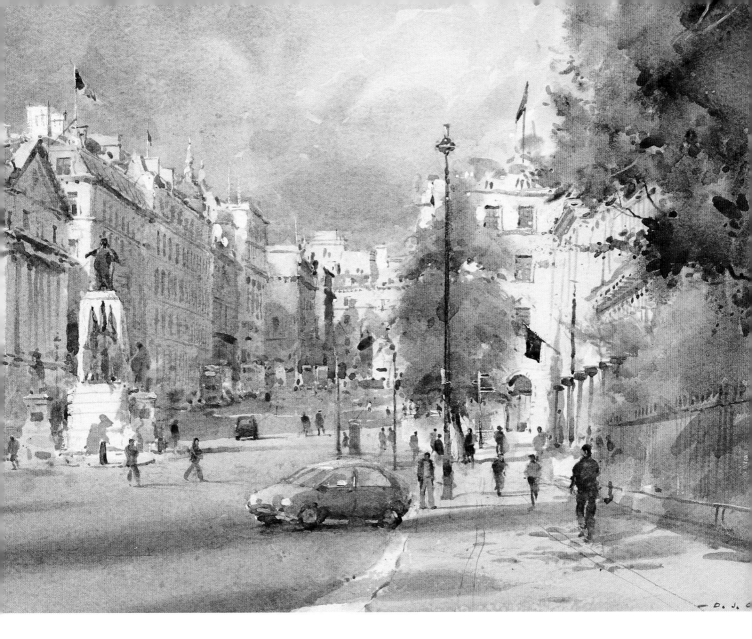

Lower Regent Street, London

WATERCOLOUR ON ARCHES PAPER

28.5 x 39cm (11¼ x 15¼in)

❝ The challenge of painting a busy city scene like this requires all one's skill and application. ❞

whiteness of the paper, adding shadows where necessary, although not loading the colour too high. Mainly, it is the sky area that defines and enhances the shapes of the buildings. I especially liked the way that the big tree shapes on the right of the composition acted as a foil for the rigid structure of the buildings opposite. It was an interesting painting to produce: loose, descriptive and all the more charming for its rawness, I think.

Contrastingly, *Barges on the Seine* is a fully resolved watercolour that I made in the studio working from all forms of reference and my memories and experience of the scene. In fact, I used elements from different photographs, taking care over the appropriate scale and positioning of everything (for example, the barges in the centre and far distance), to maximize on the interest and impact of the composition. As with *Lower Regent Street, London*, this painting started with some serious, careful drawing. Then, after applying an overall 'ghost' wash to indicate the basic shapes and colours, I worked with a succession of washes and other techniques to build up the necessary contrasts of tone, colour and surface qualities.

Locations abroad

As I have discussed (see pages 99 and 100), I enjoy the challenge of different types of subject matter and, wherever I am, essentially I will be looking for the same qualities in the subjects that I choose – originality, dynamic design and an interesting effect of light. Governed by the fact that all the materials and paintings will have to be packed and transported by plane, I suppose the only difference when painting in Europe is that I usually work on a smaller scale –

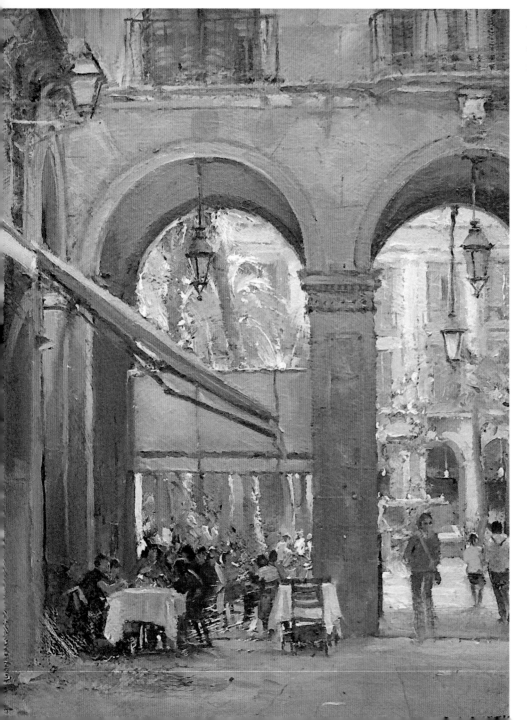

Café Study, Barcelona

OIL ON BOARD

38.5 x 28.5cm (15¼ x 11¼in)

Counter-change effects – light shapes against dark and dark against light – always add to the appeal of a subject.

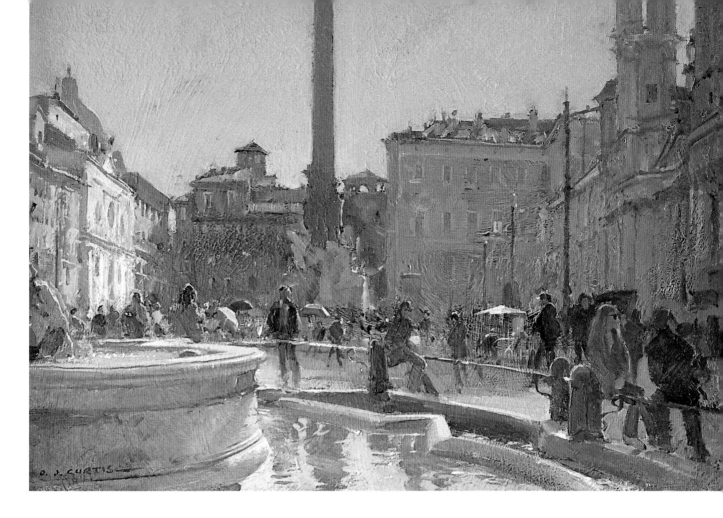

Piazza Navona, Rome

OIL ON BOARD

20 x 30.5cm (8 x 12in)

❝ When there are lots of figures coming and going, select and act quickly to place those that you think will enhance the composition. ❞

now, mostly in watercolour rather than oils – and produce a greater proportion of reference studies rather than finished paintings. Additionally, I make some adjustments to the colour palette – to include more yellows and ochres, for example – to suit the warmth and higher colour key of many subjects found in Italy, Spain and France.

In *Café Study, Barcelona* (opposite) the people are there, enjoying their coffee in the sun. I liked the contrast in scale in this scene, between the figures and the magnificent archways above, and also the contrasting light effects. There is a lot of counter-change – light shapes against dark and vice versa. Archways can be very difficult subjects to paint, particularly when taking a face-on view, as here. To avoid making the archways look too balanced and in consequence perhaps reminiscent of giant cricket stumps, I decided to break the view half-way across the second arch. You will also see that I have made full use of the canopy on the left to cut across the first arch and so interrupt the strong vertical element of the composition.

Piazza Navona, Rome (above) is a good example of a scene in which figures are constantly coming and going. You have to quickly place those that will be of value to the composition, or alternatively compile others from various references – using the arms from one figure, legs from someone else and so on. The most important consideration with figures in this sort of context is scale: they must be the right size relative to their surroundings and their placing, whether close-up or further away, in the painting.

PICTURE PROFILE
Old Willows by the Idle, Misson

Although I regularly make painting trips to various parts of the UK and abroad, sometimes I find excellent subjects right on my doorstep. *The Old Willows by the Idle, Misson* is a good example. It is a location near Doncaster, quite near where I live, and a familiar subject that I have painted on many occasions, at different seasons of the year – once in a snowstorm. This painting was made entirely on the spot, working with a loose watercolour technique on a small sheet of Arches Rough paper.

My first step was to assess the nature and content of the subject and consider this in relation to the conditions of the day and the time available. This was a windy day in late spring. I knew I had to work quickly and that the most challenging aspect of the painting would be dealing with the various greens across the foreground area and in the large trees. I judged that the best approach would be to tone down the greens and simplify these areas; otherwise the effect would be too vibrant and disjointed.

Once I had decided on the composition and had made the necessary drawing, I applied the initial 'ghost' wash (basically a variegated wash of blues and greens) and began to superimpose washes over this to suggest the form of the trees, shadow areas and so on. Essentially, the whole painting was dependent on that first, general variegated wash and, consistent with the lively, spontaneous effect that I wanted, I decided to keep everything broadly stated – the river, for example, and the distant church tower. It was a good exercise in creating the most impact from a fairly ordinary subject, through economy of means and the expressive use of paint.

Old Willows by the Idle, Misson

WATERCOLOUR ON ARCHES PAPER

28.5 x 38.5cm (11¼ x 15¼in)

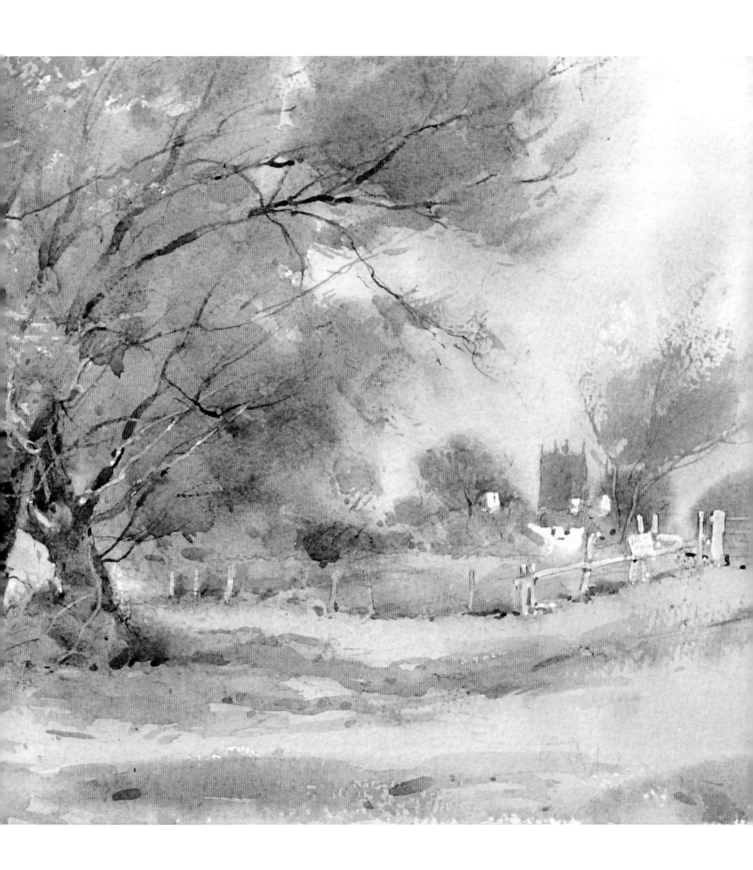

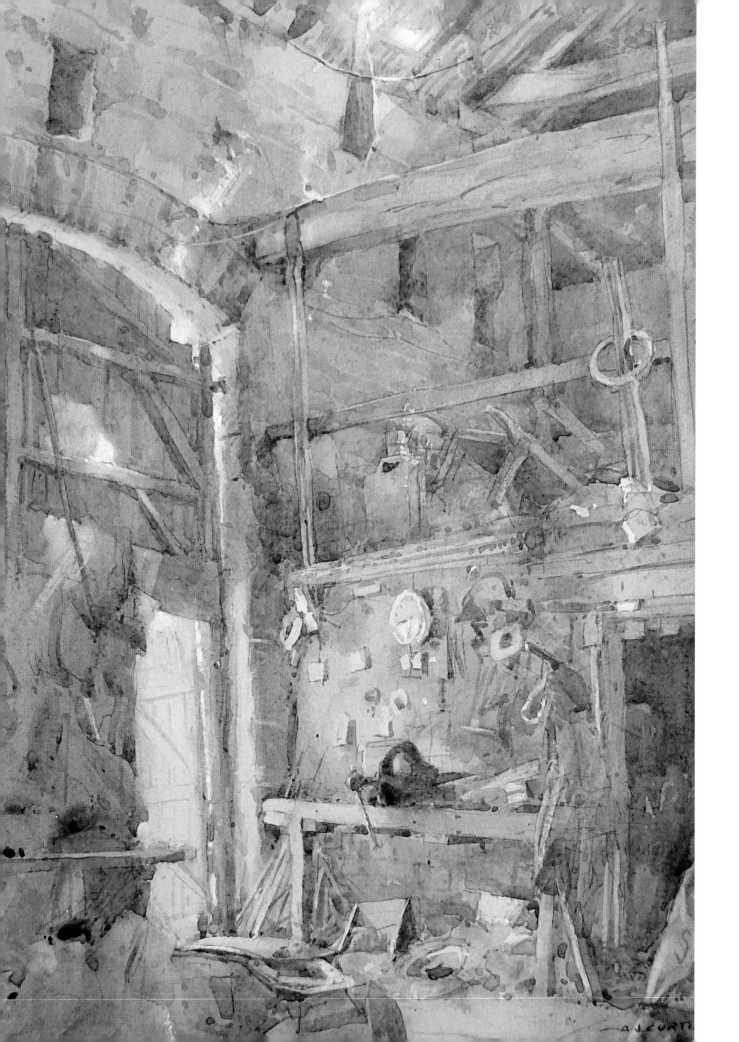

Complementary Approaches

As a figurative painter wanting to create results that are consistently expressive and individual, there is no doubt in my mind that the best approach lies in combining both *plein-air* work and studio painting. Although quite different in terms of the working process and, in consequence, the nature of the finished pictures, the two methods complement each other perfectly. The immediacy and emotive quality of *plein-air* work encourages similar objectives in studio paintings, which helps prevent them becoming laboured. In its turn, the more in-depth study from studio painting informs the speed of decision making and technique necessary when working on site.

Barn Interior,
Brampton-en-le-Morthen
WATERCOLOUR ON TWO RIVERS
TINTED PAPER
28.5 x 38.5cm (11¼ x 15¼in)

" *This old tithe barn of immense height suggested a portrait-style format to achieve a real sense of drama and scale.* "

I like the adrenaline rush and the uncertainty when you are outside: you have to be so alert and responsive to the subject matter. In contrast, in the familiar environment of the studio, there is much more time to explore ideas in some depth. But, whatever the approach, one of the most important factors in influencing the impact and success of the work is the ability to create and preserve passages of brushwork that are spontaneous and descriptive. With experience you learn to leave well alone, avoid overworking such areas and to appreciate your best-quality brushwork effects, for it is those areas that will most enliven a painting and attract interest.

Painting trips

The necessity for painting trips might depend on where you live, your degree of experience or the particular subjects that interest you. But it is always interesting to find new places and ideas and give the familiar locations a rest for a time. I enjoy painting trips and seem to travel more these days. On a recent trip to Pembrokeshire, for instance, I produced between eight and ten paintings on site, and on another trip, to Mallorca, I painted in 14 or so locations.

A potential danger with new locations is that, because time is at a premium, you may feel under pressure to find something to paint and, in doing so, make hasty choices that fail to live up to expectations. Remember, whatever the subject, it must 'move' you. I am fortunate in that I can adapt to new places quickly. Soon after I arrive at a new location I like to wander round and make a mental note of subjects that I would like to paint over the coming days. I establish a plan of attack!

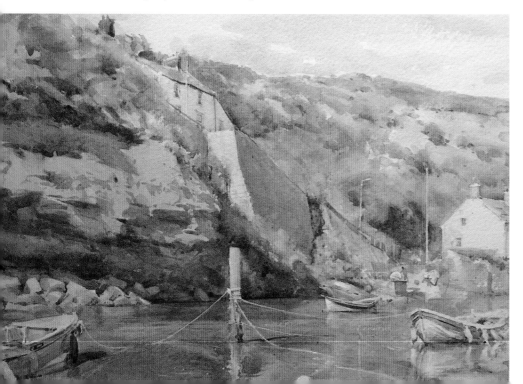

Beckside Moorings, Staithes
WATERCOLOUR ON ARCHES ROUGH
28.5 x 38.5cm (11¼ x 15¼in)

❝ *I never tire of painting at Staithes in North Yorkshire: I still manage to find interesting views, such as this one.* ❞

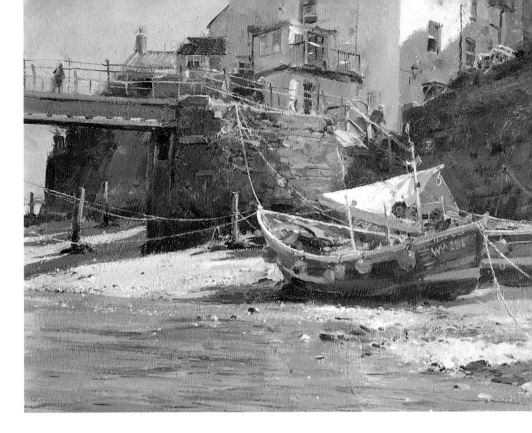

From Across the Beck, Staithes

OIL ON BOARD

25.5 x 30.5cm (10 x 12in)

❝ Whether it is a familiar location, as in this painting, or a new area, I like to spend a short while wandering around to get an idea of the best subjects to paint. ❞

Be prepared!

Whatever type of location work you are thinking of, it is always worth doing some preliminary planning. I would advise that you travel light – there will be greater opportunities to explore the area and find the more unusual subjects, away from the obvious tourist spots. The essential equipment that I recommend is: a sketching easel; a sketchbook and several soft graphite pencils; a watercolour pad or block with a small selection of paints and brushes and/or a pochade box with the basic materials for oil painting; and the necessary accessories, such as a water container, rags and turpentine.

While you don't want to be encumbered by things that you are not going to use, equally, try to ensure that you don't leave a vital piece of equipment at home – and in consequence find that you are limited in the sort of work you can attempt. Your choice of materials and equipment will obviously depend on the location and how you are going to travel there, how long you intend being away, the likely subject matter and your aims and objectives.

For my trips in the UK I travel by car, and therefore I am not so restricted in the quantity and variety of materials that I can take with me. I always take a pochade box and my big box easel, which has the advantage of being more stable than the lightweight sketching easel. Other equipment will include a good choice of prepared boards for oil painting, plus a Saunders Waterford block and six 600gsm/300lb stretched sheets of 28.5 x 39cm (11¼ x 15¼in) Arches Rough paper for watercolours. Also, I take a Binning Munro style palette and a bijou watercolour box.

If I have to walk for some distance along the coast or across the countryside, I carry a smaller selection of materials in a rucksack, with a

folding stool and a sketching easel. Alternatively I just sit on the ground, working from a pochade box. When flying to Europe, I keep to the minimum of materials. If I am working in oils, I substitute alkyd colours for some of the slower drying oil colours (cerulean, raw sienna and titanium white), thinning and mixing the colours with Sansodor rather than turpentine.

Sketches and studies

I know that photographs can be an enormous help to artists in providing specific details and information about the subject matter, but in my view they are no substitute for sketches and studies made on site. I think it is a pity that so many artists now rely principally on the camera as the means of recording ideas and information, rather than their sketchbook.

In fact, if you work only from photographs, the results, although perhaps very lifelike, will almost inevitably be unoriginal and soulless. What they will lack is the interpretation of the artist – this can only come from experiencing the subject matter and, ideally, getting to know it through observation and drawing. I still make sketches: there is no way I could have considered painting the cart, shown in *Study with Pony Trap* (opposite), for example, without first making that drawing.

Both *Study with Pony Trap* and *Old Stables, Marr Hall Farm* (opposite) are drawings made with a Flomaster pen. I used to draw a lot with this type of pen. It had a pump action, which meant that I could let it run slightly dry

Tree Study, Wentbridge Valley

LINE DRAWING, FINE FELT-TIP PEN ON
TONED PASTEL PAPER

57 x 78.5cm (22½ x 31in)

❝ *Sketches like this are very helpful in exploring the tonal contrast of a subject as a preliminary to painting.* ❞

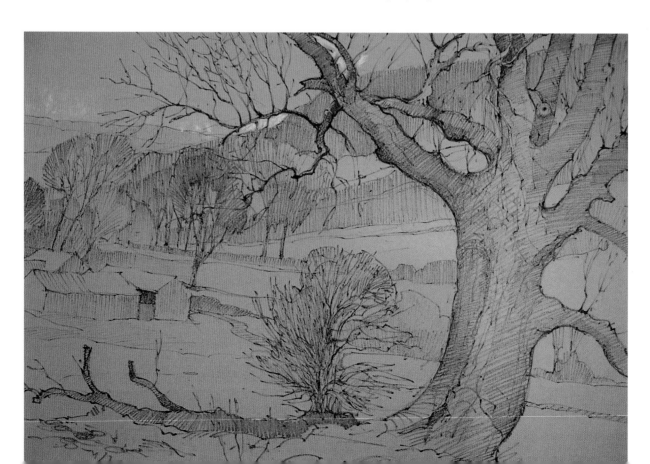

Portrait Head of a Boy

PENCIL ON CARTRIDGE PAPER

38.5 x 28.5cm (15¼ x 11¾in)

Drawing skills are fundamental to creating convincing paintings.

Old Stables, Marr Hall Farm

FLOMASTER PEN

23 x 29cm (9 x 11¼in)

Here, the drawing has helped me select and focus on those parts of the subject matter that I think will make the most interesting painting.

Study with Pony Trap

FLOMASTER PEN

23 x 29cm (9 x 11½in)

A quick sketch such as this is useful to establish the likely problem areas of the subject and how best to organize the composition.

when I wanted to include soft-toned lines and shaded areas. Then, if I gave it a couple of pumps, the ink would flow dark again. With this sort of drawing is that you can be selective and specifically focus on the elements and qualities that will be helpful in the subsequent painting. For *Portrait Head of a Boy* (above) I used a very soft pencil, which I still think is one of the simplest, quickest and most reliable ways of making a tonal reference sketch.

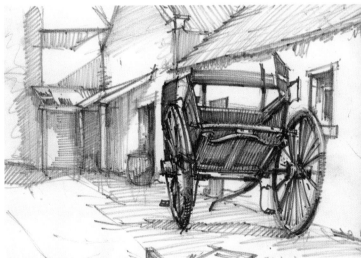

La Tanca de C'an Gaillardo
LOCATION PHOTOGRAPH

Painting *plein-air*

La Tanca de C'an Gaillardo (page 123), which I painted when I was staying
at a villa in Mallorca, demonstrates my typical working process for *plein-air*
subjects. It was a subject that I hadn't noticed until almost the end of my stay,
but seeing it in the strong, morning sunlight I felt straight away that it would
make a good painting. I liked the quality of light, especially on the old olive
tree and the building (which, incidentally, was a sort of veranda designed for
barbecues). Also, I thought that the composition would work well and, given
the particular shapes and textures, that I could achieve the greatest impact
with oils, rather than watercolour.

I chose a board prepared in the usual way – first with a coat of gesso
primer and then with one of gesso primer mixed with texture paste – and
then given a turpsy, bluish wash to block out the white surface and provide
a suitable unifying tone to work over. Working quickly, with a No. 1 worn
bristle brush and a weak mix of raw sienna and French ultramarine, I placed
the main shapes and some of the important dark tones, as you can see in
Stage 1 (opposite).

From this starting point, I went on to develop the composition and main
tones in a more positive way in Stage 2 (opposite), essentially considering the
basic tonal relationship between the sky, building, foliage and foreground,
mostly working with yellow/green and olive green/grey mixes. I knew that
the light would change quickly and therefore alter the shadows, so I needed
to identify those at this stage. Working with blocks and patches of colour, my
aim was to create a sense of the whole painting and to define the composition,
before the build-up of paint made it much more difficult to adjust things.

My colour palette for this painting included Naples yellow light, Naples
yellow, Indian yellow and buff titanium (all of which are very useful when

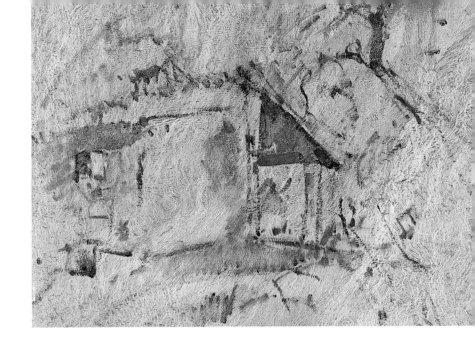

Stage 1

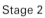 *With a No. 1 worn bristle brush, I quickly roughed-in the basic composition and some of the important dark tones.* "

Stage 2

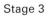 *Mostly working with blocks of yellow/green and olive green/grey mixes, I began to consider the tonal relationships throughout the painting.* "

Stage 3

" *I continued with some attention to the foreground, particularly focusing on the colourful plants and how they created a link with the rest of the composition.* "

Stage 4

❝ Next, I balanced the tones
and colours of the foliage with
those of the foreground. ❞

Stage 5

❝ With small touches here
and there to enhance some
of the tones and details, I
reconsidered the building and
foreground areas. ❞

painting in Europe and help speed up the mixing process), French
ultramarine, burnt sienna, cadmium red, cadmium orange and titanium
white. I also used two alkyd colours, raw sienna and cerulean blue, which
were chosen because they would dry faster than their oil colour equivalents.

Next, as shown in Stage 3 (page 121) I began to consider the
foreground, still working with fairly dry paint. One of the most
attractive features of this subject, I thought, was the way that the colourful
Mediterranean plants in the foreground led the eye up and into the rest of the
composition, linking with the angle of the building and that of the interesting,
tortuous tree. Also at this stage, I added more touches here and there to adjust
the tones and enhance the sense of form, as in the tree, for example.

And essentially this prepared the way for the latter stages of the
painting, in which the various adjustments and developments were made
always with the whole composition in mind. In Stage 4 (above) I worked

Detail, showing the figure and the loose brushwork technique. 〞

Detail, showing the expressively drawn strokes to suggest the flowering plants in the lower right-hand area of the painting. 〞

La Tanca de C'an Gaillardo

OIL ON BOARD

30.5 x 40.5cm (12 x 16in)

❝ I added the seated figure and, after returning to the studio, made a few final adjustments, mostly to enhance the darks. 〞

on the top right-hand corner to bring out the lightest parts of the foliage. Similarly on the left, I started to define the branch shapes, now also aiming to create more distinction between the foreground and middle distance.

After further work on the wall of the building in Stage 5 (opposite), I added a few more high-key touches of colour to the foreground, including a hint of Indian yellow. I then concentrated on the seated figure. I felt that the final painting, *La Tanca de C'an Gaillardo* (below) needed the figure to add life and a sense of scale. Back in the studio, after assessing the painting and looking at my reference photograph, I made some final adjustments – mostly to the figure, to make it a little more believable – and by enhancing the darks, to increase the overall visual 'punch' of the painting.

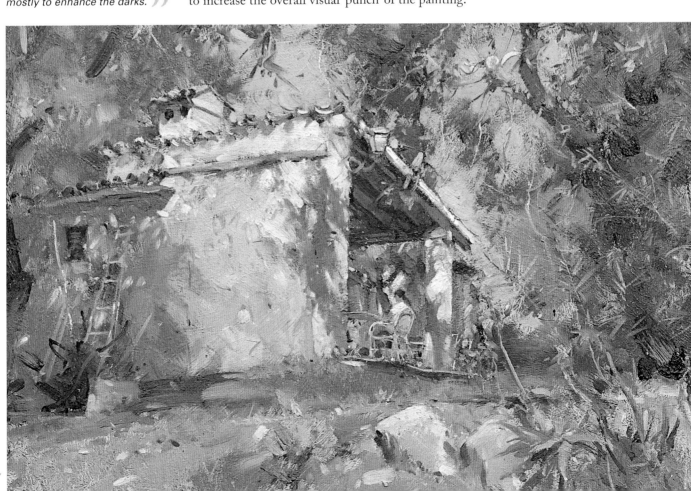

Painting from reference material, memory and experience

Inevitably, for larger and more resolved paintings, it is necessary to work in the studio. The success of this approach will depend mainly on two things: the strength of the reference material and whether it provides enough useful information to work from; and also, of course, your skill in using the information available and enhancing it with your own experience, imagination and expression.

Reference sketches do not have to be elaborate and highly detailed. Most artists develop their own 'shorthand' sketching technique, which enables them to jot down the key features of the subject quickly, perhaps also with written notes, as a reminder of what to focus on in the studio painting. Often my sketches consist of only a few lines, giving me just enough information from which to assess the strength of the composition.

Ideally, as well as referring to sketches, colour notes and photographs, it helps if you can work from memory to 'relive' the scene and so paint it with some feeling. Also, it is very useful if you can train your memory to help with the inclusion of figures, for example, and other points of interest in a painting. I will often add small figures, such as those in *Sharp Morning Light, Sandsend* (below), based on those I observe at the time, but also painted from memory and suggested with just two or three sensitive brushstrokes.

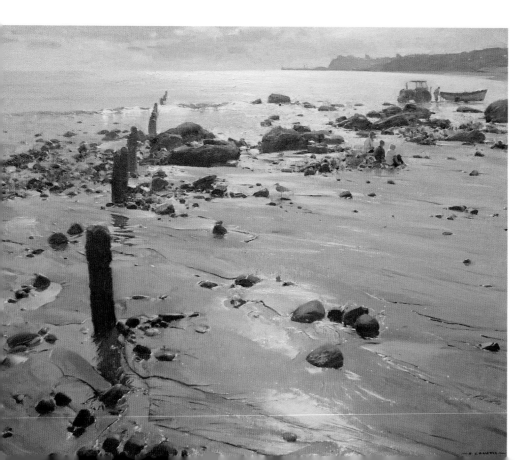

Sharp Morning Light, Sandsend

OIL ON CANVAS

61 x 76cm (24 x 30in)

❝ *I often add small figures from memory or from sketchbook studies.* ❞

Matthew by the Millpond, Monk's Mill

OIL ON BOARD

30.5 x 35.5cm (12 x 14in)

“ The particular handling qualities of oil paint were perfect for capturing the atmosphere of this quiet, intimate subject, which then acquired further impact by the late inclusion of the figure. ”

Studio work

Although the working process is quite different, as with the *plein-air* paintings, always the most important quality that I want to achieve in my studio work is a sense of mood and place. Something that helps me a great deal in this respect is the fact that, even in the winter months, I often paint outside and therefore I never really lose touch with that sort of experience – I am able to maintain something of its sense of immediacy and feeling when I am working in a more considered way in the studio. The danger in working in the studio, as I have previously mentioned, is inadvertently overstating an idea, so that there is nothing left for the viewer's imagination. A painting needs areas of mystery; unresolved areas as well as skilfully defined ones.

So, in my studio paintings I try to hold on to the lively, emotive response that I would enjoy outside, but I also adopt techniques that will help keep the paintings loose and expressive. With oil paintings, for example, I keep the amount of preliminary drawing on the canvas to the minimum number of marks, as a detailed drawing is more likely to encourage a fussy, tighter approach in the actual painting. With watercolours, although I often need to start with a carefully planned composition and drawing, I aim to keep the subsequent washes as loose and fresh as possible, creating contrasts between broadly treated and fully resolved areas. For me, the most successful studio paintings will be important, serious works that show my technique to the full, yet nonetheless look as though they were painted *in situ*.

Curiously, an aspect that is sometimes overlooked in paintings is the potential of the paint medium itself to add interest, vigour and feeling to the work. Each type of paint has its own distinctive properties and characteristics, which are always qualities to exploit when aiming to express ideas with individuality and feeling.

PICTURE PROFILE
Crisp Spring Afternoon, Staithes

Here is a good example of how the two different media, oil and watercolour, and the two different working methods, *plein-air* and studio painting, can complement each other. This painting was made in the studio, working in oils, but using a previously painted *plein-air* watercolour as the principal source of reference. In fact, I started the painting as a demonstration piece, but could only take it so far in the limited amount of time available. So I took it back to my own studio to complete it. The view is from the bridge at Staithes in North Yorkshire and, as well as the watercolour, I had some other reference material to provide more detailed information about the boats.

I always start with an underpainting when I am working in oils, essentially applying a turpsy wash of colour, quickly and loosely, to establish a tonal reference to work from. Depending on the subject matter, I may decide to start on a prepared, dry, underpainted surface or, as for this painting, apply a wet underpainting and then immediately rub out the white or very light areas with a rag. Thereafter, for *plein-air* subjects – such as *Matthew by the Millpond, Monk's Mill* (page 125), for example – the process is very much a 'one-hit', *alla-prima* one. For studio paintings, I adopt the traditional 'fat-over-lean' technique, building up effects with increasingly thicker paint.

This painting follows that approach, working with closely observed, carefully controlled layered brushwork, developed over several days. It is a painting all about light – glancing light, extreme light, reflections, lost and found, deep shadows and so on – which is a subject that I always find fascinating and challenging. *Crisp Spring Afternoon, Staithes* is an appropriate painting to conclude with, I think, because not only does it demonstrate the value of developing experience in both *plein-air* and studio work, but also it shows that, whatever the subject, given the right emphasis on composition, mood and interpretation, you can create an image of real interest and impact.

Crisp Spring Afternoon, Staithes

OIL ON CANVAS

45.5 x 61cm (18 x 24in)

Index